Paintings Prayers & Passages

an illuminated journey

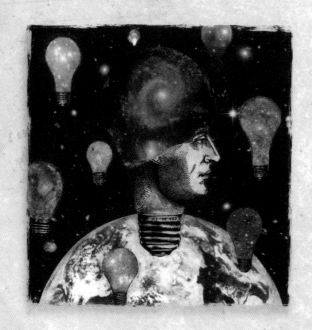

"Holy Spirit think through me,
till your ideas are my ideas."

Amy Carmichael

I want to thank
and dedicate this book
to Keith,
my husband, my best friend,
who has cheered me on for so many years,
encouraging me and supporting me in
my artistic journey
and walk with God.

The Story Behind the Art

At one time or another most of us long for more…more love, more meaning, more purpose and power, more of God; someone and something greater than ourselves to be a part of. It is out of that longing that I seek close communion, conversation and collaboration with my Creator. For me, life, prayer and art cannot be separated. This prayer book is an expression of yearning, listening, responding, without a formula or specific agenda. It is a kind of witness to a creative, spiritual journey with its peaks and valleys. Most of the artworks I've made and prayers I've written relate to what I was going through at a specific time, or what someone close to me was going through. In preparing for this book, I painted backgrounds, scanned or photographed some of my paintings, compiled texts and images, added design elements in Photoshop, and then digitally assembled them. As I look back, I am reminded that God is always with me, loving me, some-times creating with me, speaking my language. My desire is that this book will relate to your own inner journey and inspire you with hope and encouragement.

As an artist, I haven't settled into a neat niche and can't say, "I do this particular kind of art or that kind." Instead my art tends to flow one way and then another, like phases or seasons, changing, but not settling into one mode of expression. This can be an advantage when teaching art in a school like I did for over eight years, but it can be frustrating as an artist. Now, I am going with the flow and am grateful for the opportunity to teach in my studio and at events, and express my journey with paint, collage, and words. Instead of asking God to bless what I'm doing, I am asking Him what He is doing and how I can join Him.

As a teenager I wished God would send me a postcard to tell me what He thought of a particular situation, to let me know He was listening, or to tell me what I should do. I am still fascinated by the idea of getting a postcard from God, but now I know He wants a more personal relationship with me than that. He wants to walk with me, to take me along with Him. God really does love each one of us because we are His children. Why did it take me so long to really believe and experience that depth of love?

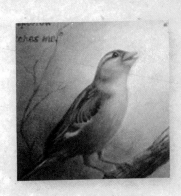

Life often doesn't look how we think it should with its pain and loss, and yet there is beauty and hope. It's filled with paradox. Like many (maybe even most) people, I am not a person whose life has come in a neat box tied with a pretty bow. There have been gut-wrenching losses, but I have also been immensely blessed with some lifelong loving relationships that have weathered all sorts of storms. And when no one seemed to be there, God was. He uses all sorts of things to tell me He loves me. One day He used a family of sparrows to speak to me, and through the painting made from that experience I am continually reminded of His loving care.

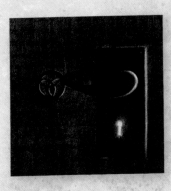

In 2000 I went back to college as an adult learner, and five years later earned a Bachelor of Fine Arts degree in Painting at Marylhurst University. My thesis project included a series of seven paintings on the "I AM" statements of Jesus recorded by the Apostle John. This project pushed my skill and

perseverance. Our friend, Mark Morse, who read through my thesis paper, thoughtfully edited much of the text in the "I AM" section of this book. As I researched the symbolism and relevant Scripture of the metaphors Jesus used to describe himself, my appreciation for the power and meaning of metaphor and symbolism grew. The last "I AM" painting wasn't completed until this year, 2011, seven years after the thesis show. I knew there was one missing, but I couldn't visualize it back then. In each of the paintings I worked to experience the symbolism. For example, I used our own grape leaves and photographed grapevines as reference for "The True Vine." I bought matzoh bread and challah at the store, then drew and painted them. In the "I AM the Resurrection and the Life" I used an Easter Lily as reference and bought the butterfly eggs at a pet store to draw each stage of metamorphosis. For the paintings with more abstract themes, I researched as much as I could before drawing the images. The content of each painting was symbolic, and I allude to the one I knew was missing in "I AM the Door of the Sheep".

In 2004 I had shoulder surgery and for nearly a year afterward I couldn't hold a paintbrush up at an easel. I was feeling the need to paint but without the motion or control I previously had it was clear I would not be

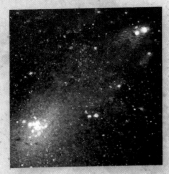

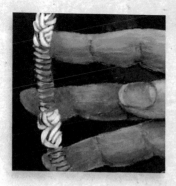

able to paint in my usual realistic style. One day as I was doing my physical therapy I imagined holding a paintbrush instead of a soup can, and with that new idea I began painting down on the floor. During that time the Hubble space pictures were appearing in magazines, and I was mesmerized by the abstract beauty and mystery of the images. In the evenings as we sat in the hot tub I got some relief from the shoulder pain, and I looked at the stars, questioning, longing, and realizing that God was so much greater than I could ever understand or imagine. The cosmic paintings were born during that time and now those techniques often work their way into many other pieces of my art. When I feel a cosmic painting coming on, I delve in and enjoy this uninhibited process of art making. The freedom of splattering, spraying, tipping, and layering paint on a larger scale can be exhilarating. It's amazing that painting in this way came out of my pain and limitation.

While recovering from shoulder surgery, I also began art journaling. It went very slow at the beginning. I thought I would never have another idea. I could barely move my arm or hand, so at first I read books and gathered collage fodder with my non-dominant hand. Then I started doodling with a pen in 2-inch boxes I had drawn in my watercolor pad. I added writing, painting, and collage. I was now Art Journaling....and it changed my life. Now I can't imagine life without it. I have all sorts of journals, and try not to pressure myself to have to make "good art" in them. They give me a place to play, experiment, explore ideas, express passages, pray with or without words, and listen and respond spontaneously.

There is no limit to what subjects can be included in art journaling. Mine are as varied as getting through childhood pain, exploring the golden ratio, and visualizing the story of the Samaritan woman at the well. I love the process!

A few years ago our family went through what we call "a series of unfortunate events." Aren't some years like that? We look back and say, "Only by God's grace did we make it through!" During that period things got so overwhelming I didn't even have any words to pray. I needed to hear from God. I needed to talk to Him. I wanted to, but I was utterly empty. So at least once a week I went to the library, my place of solace. Over a period of a few months I checked out every prayer book I could find. I began to copy prayers of the saints and Scripture verses into a 3" x 5" spiral bound blank book with lines on one side. I carried this book with me everywhere and read and prayed through the prayers as I waited in the car, before I went to bed, and when I felt

depressed. When the book was full, I began another, adding images and writing some of my own prayers. I found that writing a prayer based on Scripture made it more personal and applicable to my life. As I kept on making the prayer books, I began incorporating more images, colors and doodles into what I now call visual prayers.

Up until the time I worked on the "I AM" series, I did not think I would ever portray the person of Christ. Who could capture the face of God? Then I was challenged by a couple of people to research icons and their purpose. I was introduced to the Pantokrater icon "Ruler of All" from St. Catherine's Monastery in Sinai, which show both the justice and mercy of Christ in His face. I used it in personal worship and found it helped me stay focused longer. It was like a photo of someone I loved, not the actual object of worship, but a reminder of the reality of Christ, God incarnate, in my world, in me.

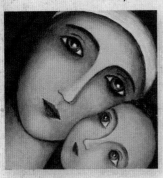

Shortly after that, I wanted to try and paint an icon using the measurements and format of traditional icons. I asked God about it and one day began the "Madonna and Child." It didn't even seem like I was painting it and as I worked I was filled with joy. The icon of the Lord Jesus "Come" was done during a time when I could see Him in my mind reaching out to me. That Sunday at Church, before the hands were finished, our pastor preached on Jesus calling Peter to get out of the boat and "come," the same word I had just painted on the icon earlier in the week.

I believe Jesus is still asking us to come with Him. The journey is not finished. In some ways, it has just begun. I find that exciting. All I want is to experience His loving presence, and never forget to be grateful.

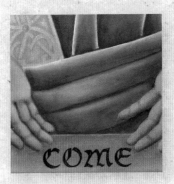

COME

LORD,
Bless us with your presence,
Lead us with your peace,
Ignite us with your passion,
Infuse us with your power, and
Fulfill us with your purpose.

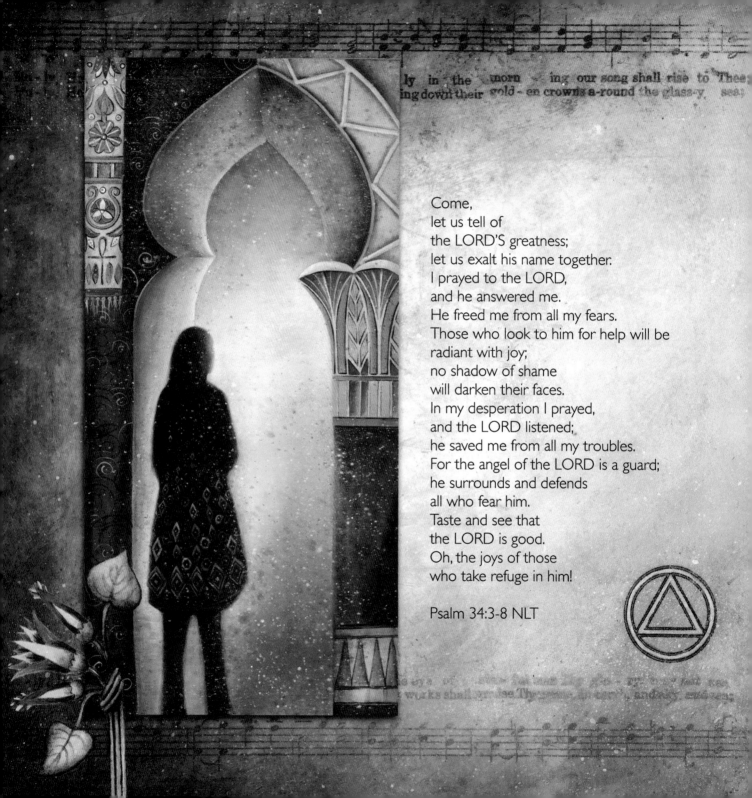

Come,
let us tell of
the LORD'S greatness;
let us exalt his name together.
I prayed to the LORD,
and he answered me.
He freed me from all my fears.
Those who look to him for help will be
radiant with joy;
no shadow of shame
will darken their faces.
In my desperation I prayed,
and the LORD listened;
he saved me from all my troubles.
For the angel of the LORD is a guard;
he surrounds and defends
all who fear him.
Taste and see that
the LORD is good.
Oh, the joys of those
who take refuge in him!

Psalm 34:3-8 NLT

Ho-ly, Ho-ly, Ho-ly! Mer-ci-ful and Might-y! God in Three Per-sons, [illegible] Trin-[illegible]!
Cher-u-bim and ser-a-phim fall-ing down be-fore Thee, Which wert and art, and ev-er-[illegible] shalt be.

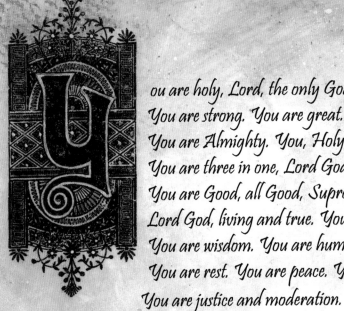

ou are holy, Lord, the only God, and your deeds are wonderful.

You are strong. You are great. You are the Most High.

You are Almighty. You, Holy Father, are King of heaven and earth.

You are three in one, Lord God, all Good,

You are Good, all Good, Supreme Good,

Lord God, living and true. You are love.

You are wisdom. You are humility. You are endurance.

You are rest. You are peace. You are joy and gladness.

You are justice and moderation.

You are all our riches, and you suffice for us.

You are beauty. You are gentleness. You are protector.

You are our guardian and defender. You are courage.

You are our haven and our hope. You are our faith, our great consolation.

You are our eternal life, great and wonderful Lord,

God Almighty, merciful Savior."

— St. Francis of Assisi, 1181–1226

On-ly Thou art ho-ly; there is none be-side Thee Per-fect in power, in love, and pu-ri-ty.
Ho-ly, Ho-ly, Ho-ly! Mer-ci-ful and Might-y! God in Three Per-sons, bless-ed Trin-i-ty! A-[men].

Who else has held the oceans in his hand?
Who has measured off the heavens with his fingers?
Who else knows the weight of the earth
or has weighed the mountains and hills on a scale?

Isaiah 40:12 NLT

"LORD, help!" they cried in their trouble,
and he saved them from their distress.
He calmed the storm to a whisper and stilled the waves.
What a blessing was that stillness as he brought them safely into harbor!
Let them praise the LORD for his great love
and for the wonderful things he has done for them.

Psalm 107:28-31 NLT

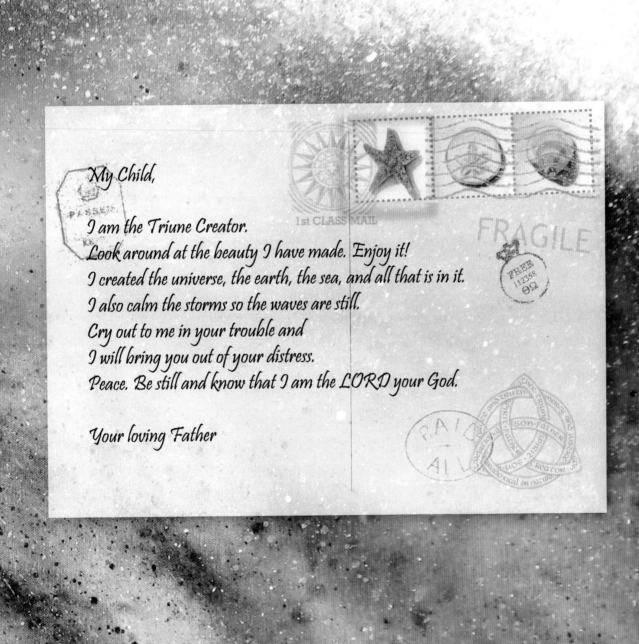

My Child,

I am the Triune Creator.
Look around at the beauty I have made. Enjoy it!
I created the universe, the earth, the sea, and all that is in it.
I also calm the storms so the waves are still.
Cry out to me in your trouble and
I will bring you out of your distress.
Peace. Be still and know that I am the LORD your God.

Your loving Father

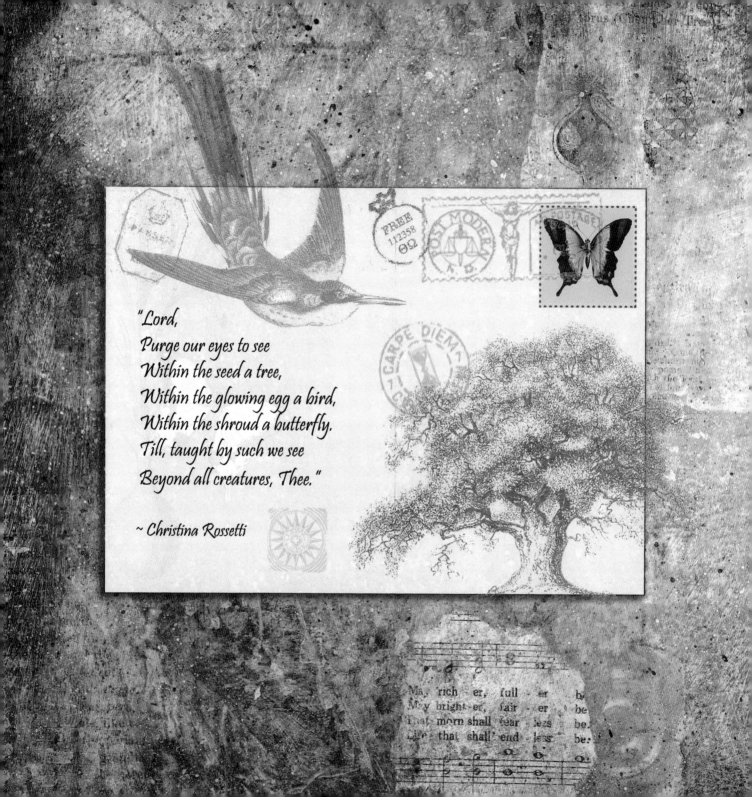

"Lord,
Purge our eyes to see
Within the seed a tree,
Within the glowing egg a bird,
Within the shroud a butterfly.
Till, taught by such we see
Beyond all creatures, Thee."

~ Christina Rossetti

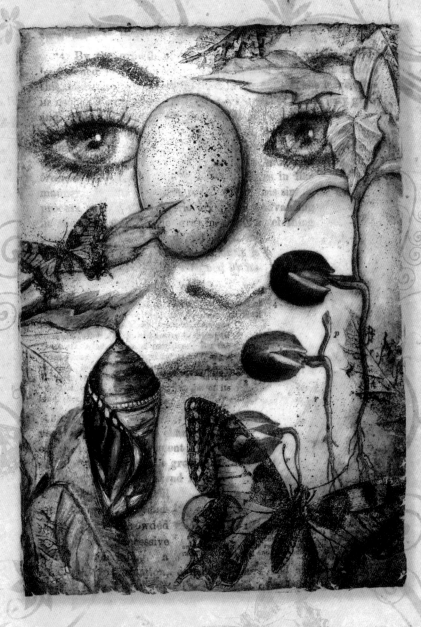

for through him God created everything
in the heavenly realms and on earth.
He made the things we can see and the things we can't see—

Colossians 1:16a NLT

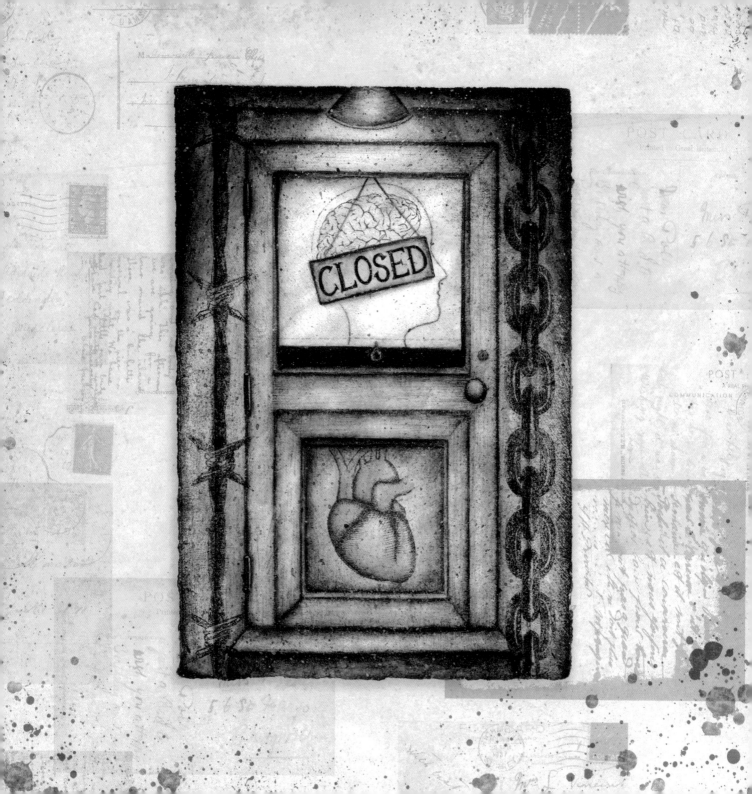

My Dear Child,
I long to be close to you,
for you to return to me.
Will you open the closed door of your heart and mind?
I will not push in. I am waiting…
waiting for you to be open so I can share life with you,
beautiful and abundant,
because I love you.

Your Loving Father

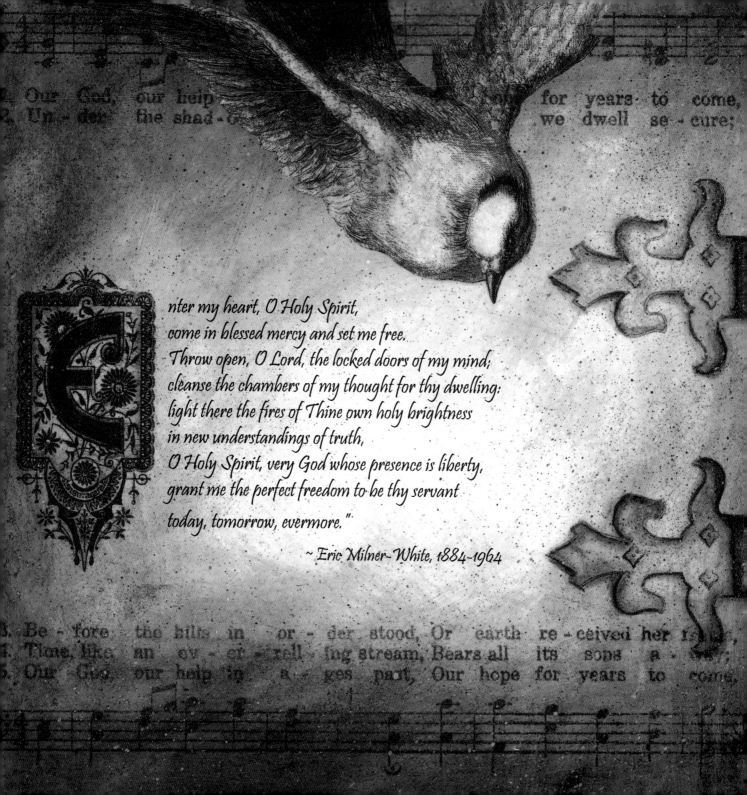

1. Our God, our help for years to come,
2. Un-der the shad- we dwell se-cure;

nter my heart, O Holy Spirit,
come in blessed mercy and set me free.
Throw open, O Lord, the locked doors of my mind;
cleanse the chambers of my thought for thy dwelling;
light there the fires of Thine own holy brightness
in new understandings of truth,
O Holy Spirit, very God whose presence is liberty,
grant me the perfect freedom to be thy servant

today, tomorrow, evermore."

~ Eric Milner-White, 1884-1964

3. Be-fore the hills in or - der stood, Or earth re-ceived her
4. Time, like an ev-er-roll ing stream, Bears all its sons a-
5. Our God, our help in a - ges past, Our hope for years to come,

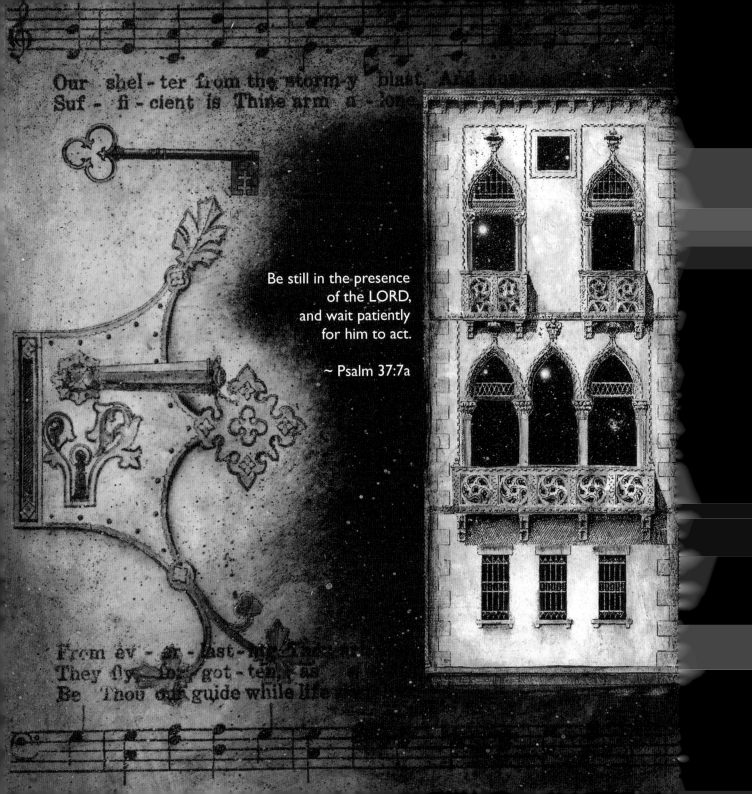

Be still in the presence
of the LORD,
and wait patiently
for him to act.

~ Psalm 37:7a

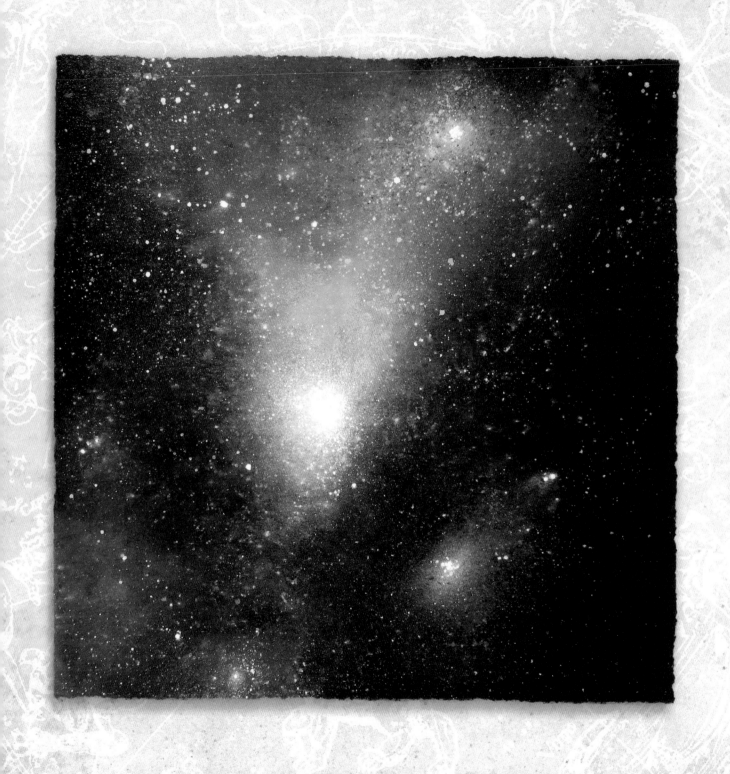

Look up into the heavens.
Who created all the stars?
He brings them out like an army,
one after another, calling each by its name.
Because of his great power
and incomparable strength, not a single one is missing.
Have you never heard? Have you never understood?
The LORD is the everlasting God,
the Creator of all the earth.
He never grows weak or weary.
No one can measure the depths of his understanding.
He gives power to the weak
and strength to the powerless.

Isaiah 40:26, 28-29 NLT

"Lord God, through the light of nature you have aroused in us a longing for the light of grace, so that we may be raised in the light of your majesty. To you I give thanks, Creator and Lord, that you have allowed me to rejoice in your deeds. Praise the Lord you heavenly harmonies and you who know the revealed harmonies. For from him, through him and in him, all which is perceptible as well as spiritual; that which we know and that which we do not know, for there is still much to learn."

~ Johannes Kepler

My Dearest Child,

I am your sufficiency. I have known you from
the beginning. I know everything about you: your past, your present,
your future, your thoughts, your feelings, your secrets, your hopes and fears.
I know you better than you know yourself,
and I love you! I am always with you.

I am listening,
Your loving Father

O LORD, you have examined my heart
and know everything about me.
You know when I sit down or stand up.
You know my thoughts even when I'm far away.
You see me when I travel
and when I rest at home.
You know everything I do.
You know what I am going to say
even before I say it, LORD.
You go before me and follow me.
You place your hand of blessing on my head.
Such knowledge is too wonderful for me,
too great for me to understand!"

Psalm 139:1-6 NLT

I can never escape from your Spirit!
I can never get away from your presence!
If I go up to heaven, you are there;
If I go down to the grave, you are there.
If I ride the wings of the morning,
if I dwell by the farthest oceans,
even there your hand will guide me,
and your strength will support me.
I could ask the darkenss to hide me
and the light around me to become night—
but even in the darkness
I cannot hide from you.
To you the night shines as bright as day.
Darkness and light are the same to you.
You made all the delicate, inner parts of my body
and knit me together in my mother's womb.
Thank you for making me so wonderfully complex!
Your workmanship is marvelous—
how well I know it.

Psalm 139:7-14 NLT

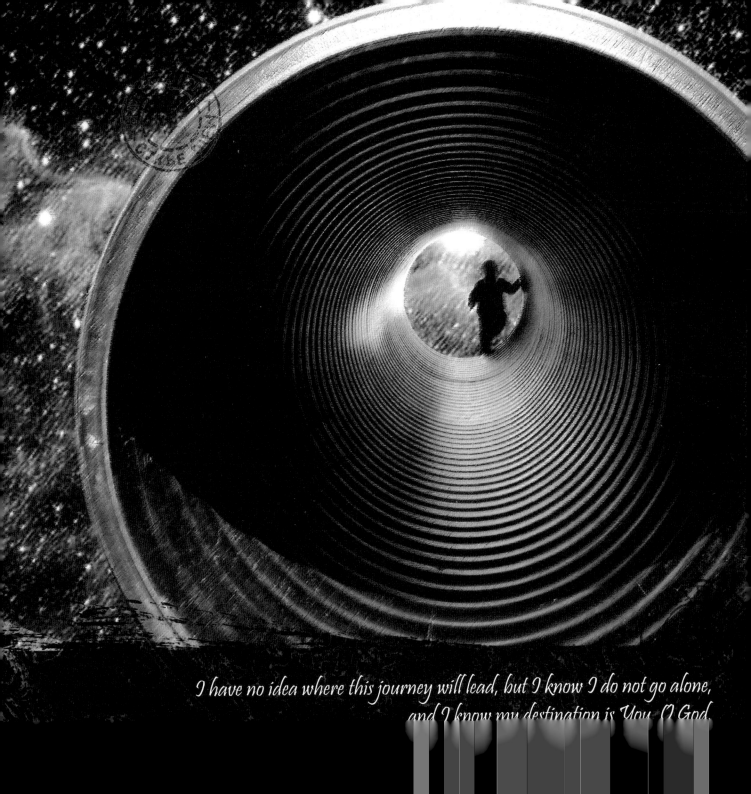

I have no idea where this journey will lead, but I know I do not go alone, and I know my destination is You, O God.

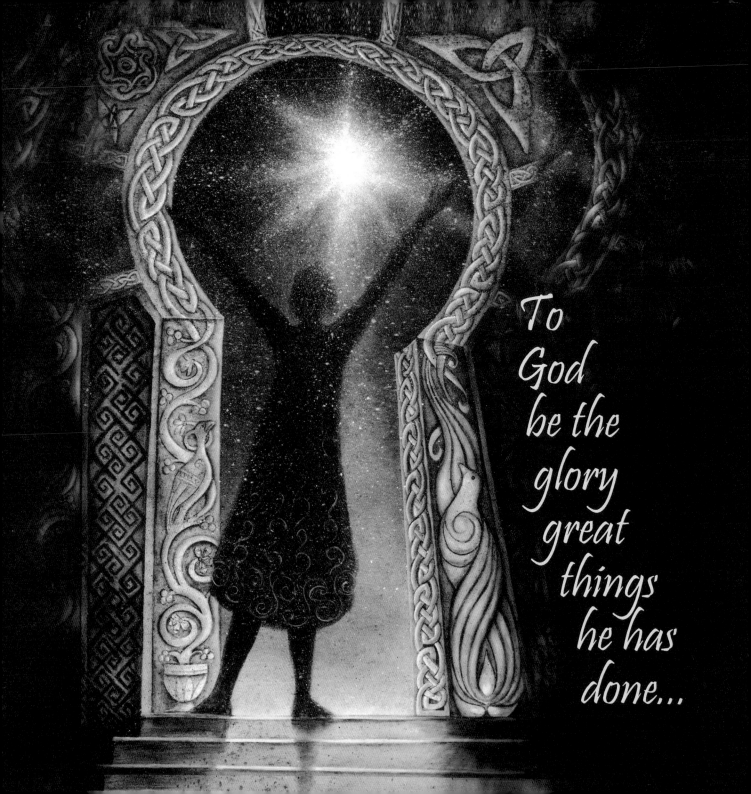

To
God
be the
glory
great
things
he has
done...

O Gracious and Glorious God,
Creator of everything in heaven and on earth,
I pray that from your glorious,
unlimited resources You will give me
mighty inner strength through Your Holy Spirit.
And I pray that Christ will be more and more
at home in my heart as I learn to trust You more.
May I truly know and grow into Your marvelous love.
And may I have the power to understand how long,
how high, and how deep Your love really is.
May I experience the love of Christ,
even though I will never fully understand it.
Then I will be filled with the fullness of life and power
that comes from You God.
Now to you O God, be all glory!
By Your mighty power at work within me
You are able to accomplish
infinitely more that I even dare ask or hope.
Amen.

~ based on Ephesians 3:15-20

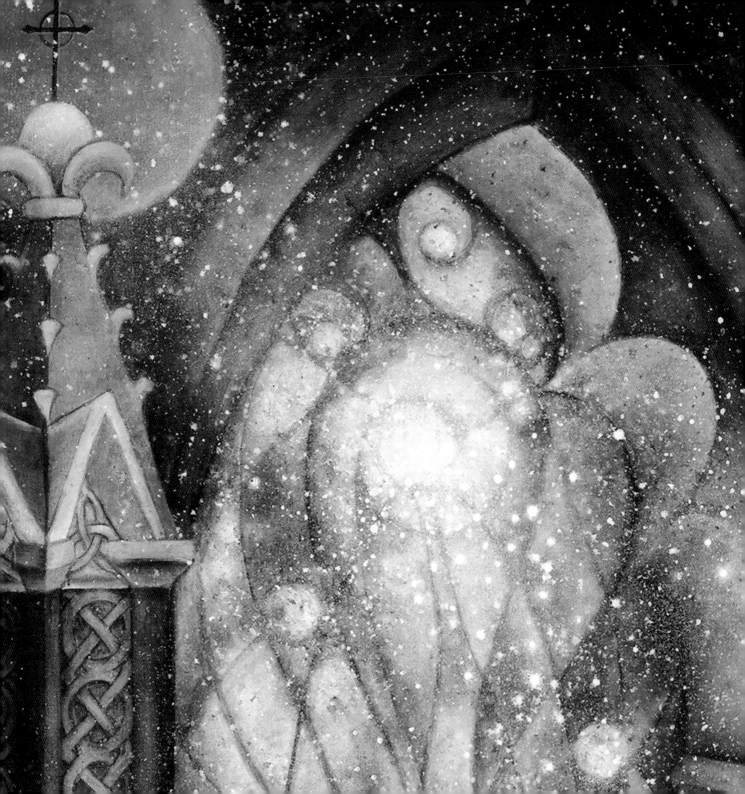

"Almighty and Eternal God,
so draw my heart to You,
so guide my mind,
so fill my imagination,
so control my will,
that I may be wholly Yours,
utterly dedicated to You;
and then use me I pray,
as you will, and always to
Your glory and
for the welfare
of Your people,
through my LORD
and Savior
Jesus Christ.

Amen"

*- adapted from the
Book of Common Prayer*

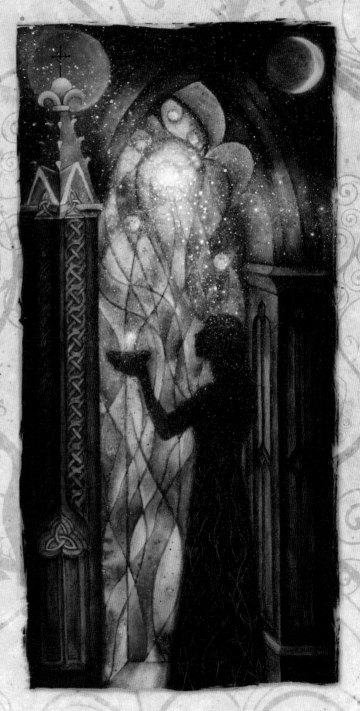

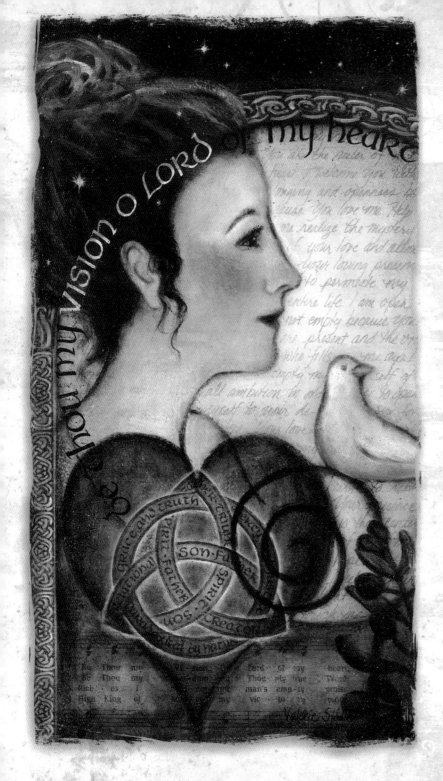

Be thou my vision O Lord of my heart

~ Vision that:
gives God the glory,
is driven by passion,
motivates with enthusiasm,
shines light in the darkness,
causes a breakthrough,
brings redemption,
strengthens the weak,
invites God's blessing,
allows space for dreaming,
brings joy to the process,
leads to right action,
answers the question,
"Why are we doing this?"
shows us how to live
in God's kingdom~
Vision that gives
purpose and
meaning.

Circle me Lord,
keep wisdom within
and selfish ambition without.
Circle me Lord,
keep your vision in front of me
and insecurity behind.

LORD help us, your servants, see what You are doing.
Reveal to us Your glory and show us our part in Your work.
Let your favor, grace, and beauty, O Lord God, rest upon us.
Direct and prepare our hearts;
provide the work of our hands for us.
Yes, confirm the work of our hands.

~ based on Psalm 90:16-17

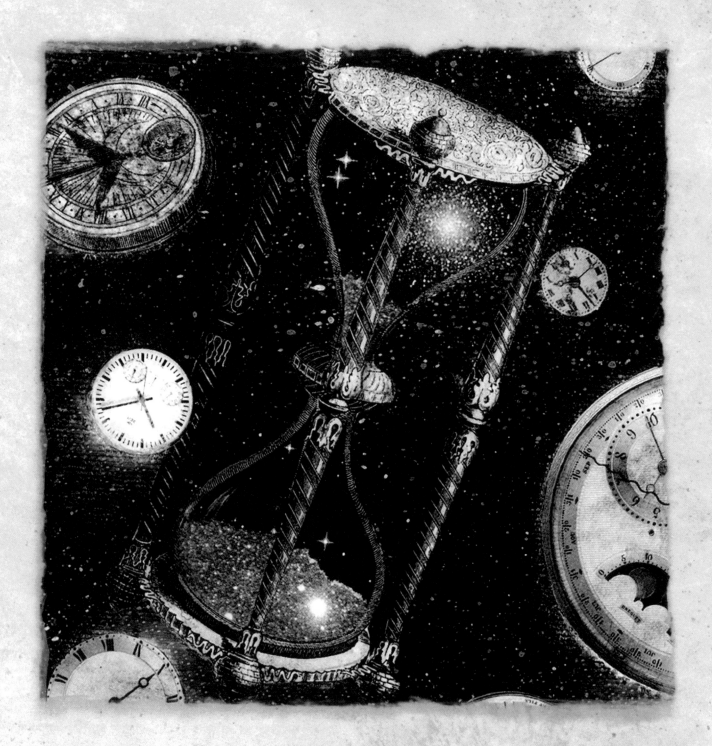

There is a time for everything,
and a season for every activity under the heavens:
a time to be born and a time to die,
a time to plant and a time to uproot,
a time to kill and a time to heal,
a time to tear down and a time to build,
a time to weep and a time to laugh,
a time to mourn and a time to dance,
a time to scatter stones and a time to gather them,
a time to embrace and a time to refrain from embracing,
a time to search and a time to give up,
a time to keep and a time to throw away,
a time to tear and a time to mend,
a time to be silent and a time to speak,
a time to love and a time to hate,
a time for war and a time for peace.

Ecclesiastes 3:1-8 NIV

O most merciful LORD,
You are a compassionate parent to your children.
You know how weak we are, our life is short.
Our days are like the flowers that bloom and then die.
You remember we are but stardust,
the wind blows and we are no more on this earth.
But your love LORD remains forever,
beyond this mortal life,
to those who cherish You.

~ based on Psalm 103:13-17

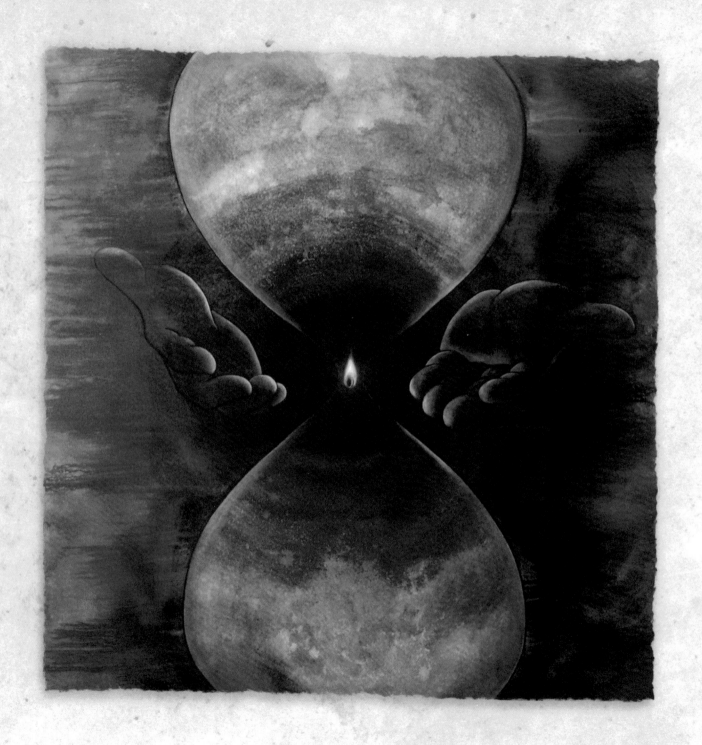

Note to self:

Be fully present in the present moment,
Right here, right now.
God is present!
Accept this moment:
See it, hear it, smell it, taste it, feel it.
Be thankful
For this moment,
For His presence,
For the gift of life
to fully live
Now!

You watched me as I was being formed in utter seclusion,
as I was woven together in the dark of the womb.
You saw me before I was born.
Every day of my life was recorded in your book.
Every moment was laid out
before a single day had passed.
How precious are your thoughts about me, O God.
They cannot be numbered!
I can't even count them;
they outnumber the grains of sand!
And when I wake up,
you are still with me!

Psalm 139:15-18 NLT

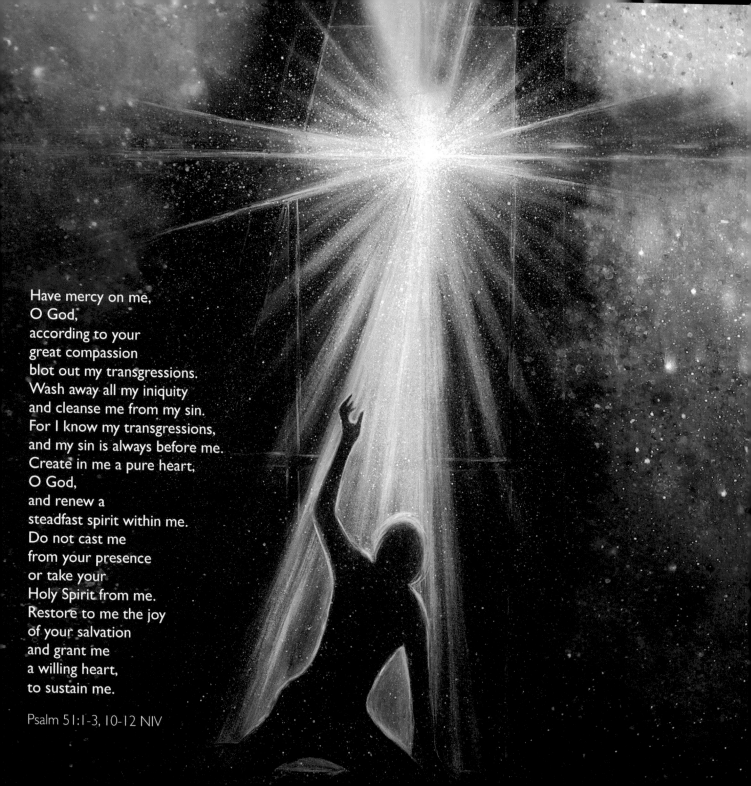

Have mercy on me,
O God,
according to your
great compassion
blot out my transgressions.
Wash away all my iniquity
and cleanse me from my sin.
For I know my transgressions,
and my sin is always before me.
Create in me a pure heart,
O God,
and renew a
steadfast spirit within me.
Do not cast me
from your presence
or take your
Holy Spirit from me.
Restore to me the joy
of your salvation
and grant me
a willing heart,
to sustain me.

Psalm 51:1-3, 10-12 NIV

My Child,

I am your Redeemer. Come to me.

I love you!

I sent my Son to save you.

Believe in Him. Trust me with the secret parts of your heart.

Admit openly your wrongs to me. I am compassionate and full of mercy.

I am faithful to forgive you and will wash all the wickedness from your heart.

Let me redeem your life, and renew your spirit.

Your loving Father

FRAGILE
HANDLE WITH CARE

1st CLASS MAIL

PAID ALL
ΘΩ

AIR MAIL

AIR MAIL
ไปรษณีย์อากาศ

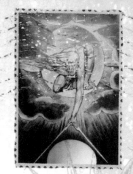

"Almighty God,
who art beyond the reach
of our highest thought,
and yet within the heart of the lowliest:
come to us we pray Thee,
in all the beauty of light, in all the tenderness of love,
in all the liberty of truth;
Mercifully help us to do justly, to love mercy,
and to walk humbly with Thee.
Sanctify all our desires and purposes, and upon each of us
let Thy blessing rest, through Jesus Christ our Lord."

- adapted from the Service Book and ordinal of the Presbyterian Church of Africa

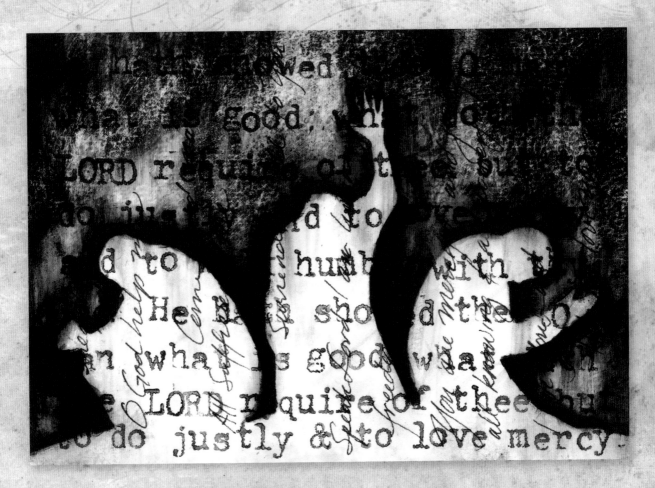

"'God opposes the proud but favors the humble.'
So humble yourselves under the mighty power of God, and at the right time
he will lift you up in honor. Give all your worries and cares to God, for he cares about you.

1 Peter 5:5-6 NLT

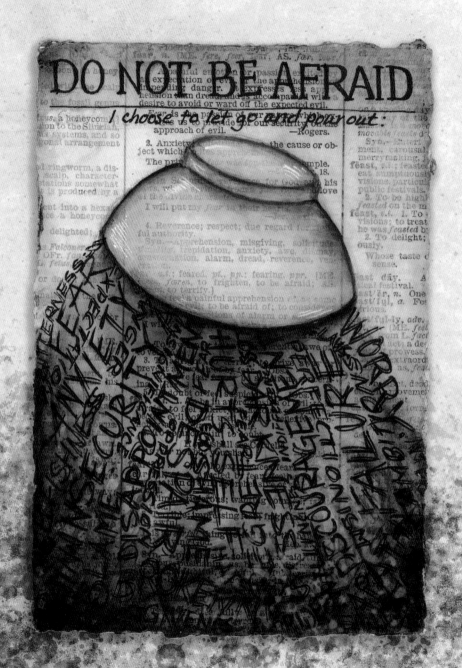

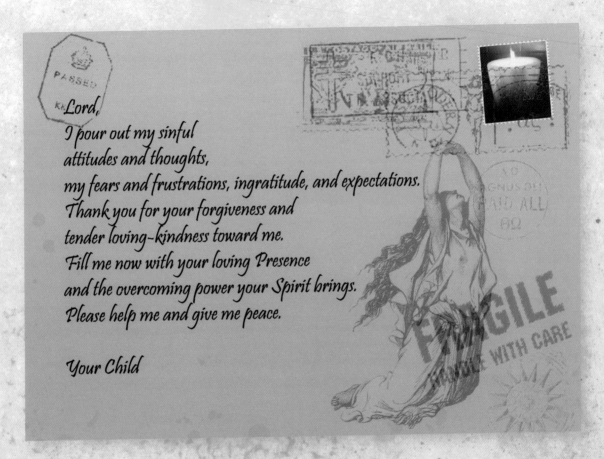

Let go & trust God's goodness

Lord,
I pour out my sinful
attitudes and thoughts,
my fears and frustrations, ingratitude, and expectations.
Thank you for your forgiveness and
tender loving-kindness toward me.
Fill me now with your loving Presence
and the overcoming power your Spirit brings.
Please help me and give me peace.

Your Child

His perfect love casts out fear

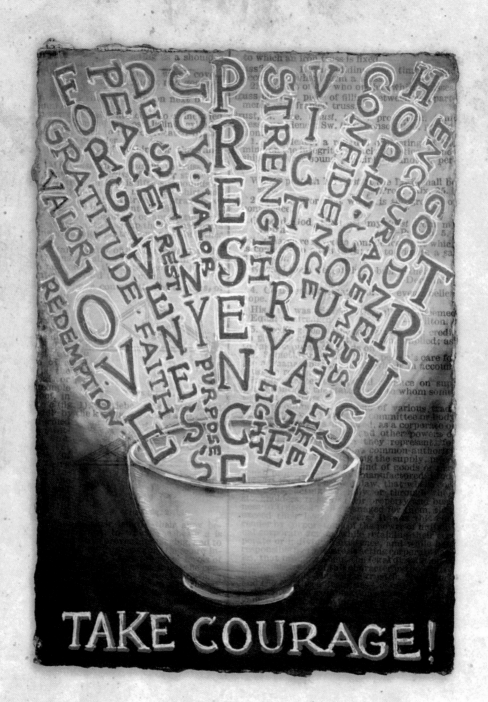

TAKE COURAGE!

*GRACE * MERCY*

When God our Savior revealed his kindness and love,
he saved us,
not because of the righteous things we had done,
but because of his mercy.
He washed away our sins, giving us a new birth
and new life through the Holy Spirit.
He generously poured out the Spirit upon us
through Jesus Christ our Savior.
Because of his grace he declared us righteous
and gave us confidence that we will
inherit eternal life.

Titus 3:4-7 NLT

SPIRIT * FILLED * LIFE

But the Holy Spirit produces this kind of fruit in our lives:
love, joy, peace, patience, kindness, goodness, faithfulness,
gentleness, and self-control.
There is no law against these things!

Galatians 5:22-23 NLT

LOVE * JOY * PEACE

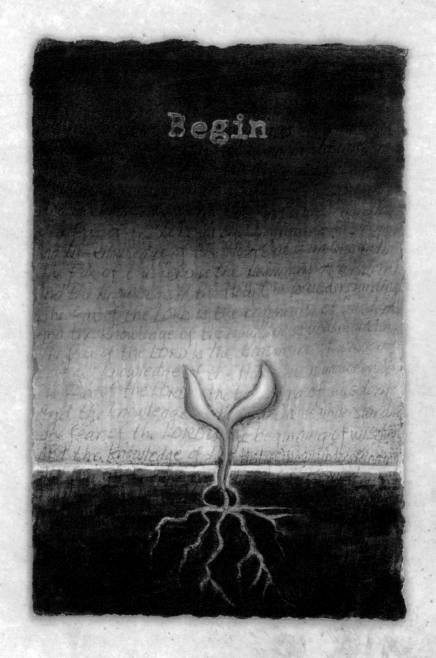

You, O God,
have planted your seed in my heart-
hidden from all but You.
Please make it grow out of the darkness and
into your marvelous light
to produce your fruit.

... anyone who belongs to Christ has become a new person.
The old life is gone;
a new life has begun!

2 Corinthians 5:17 NLT

1st CLASS MAIL

The fear of the LORD is the beginning of wisdom,
and knowledge of the Holy One is understanding.

Proverbs 9:10 NIV

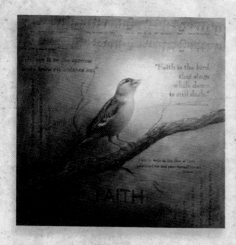
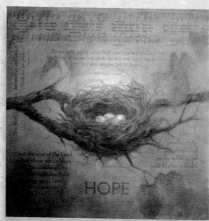
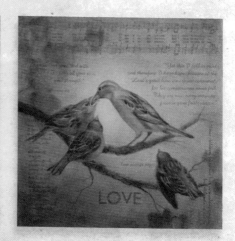

"His eye is on the sparrow, and I know He watches me..."

This painting, in three sections came after nearly five months of artist's block. I had done a single pastel based on the quote by Rabindranath Tagore, "Faith is the bird that sings while dawn is still dark" at the beginning of a dark time involving loss of relationships, and the beginning of a process dealing with pain from the past. During that time the common sparrow seemed to best symbolize me. The sparrow is one of the most common birds on the planet. It is found on every continent and is sometimes considered a pest. I wanted to portray the idea of faith, hope, and love with the bird singing in the dark, the hope of eggs in a nest, and the practical aspect of love represented by a mother bird feeding her babies. The needs of my family and my part in meeting those needs kept me going.

The challenge I faced in making this piece was that I didn't have any suitable photo reference of sparrows. I tried to wing it from what I had and books from the library, but it just didn't work well. Then I prayed and asked for sparrows. Within two weeks on a Saturday morning, a family of sparrows spent the entire morning on our patio; a mother and three babies. I spent the entire morning on my stomach taking photos from the inside of the patio door. This experience is an encouragement to me that God loves each of us and cares about even the little things in our lives.

"Faith is the confidence that what we hope for will actually happen;
it gives us assurance about things we cannot see."

Hebrews 11:1 NLT

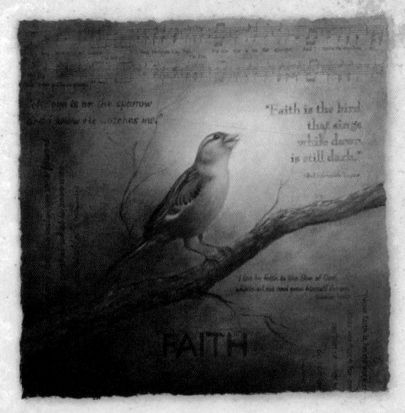

I will never forget this awful time, as I grieve over my loss.
Yet I still dare to hope when I remember this:
The faithful love of the LORD never ends!
His mercies never cease.
Great is his faithfulness;
his mercies begin afresh each morning.
I say to myself, "The LORD is my inheritance;
therefore, I will hope in him!"
The Lord is good to those who depend on him,
to those who search for him.
So it is good to wait quietly
for salvation from the LORD.

Lamentations 3:20-26 NLT

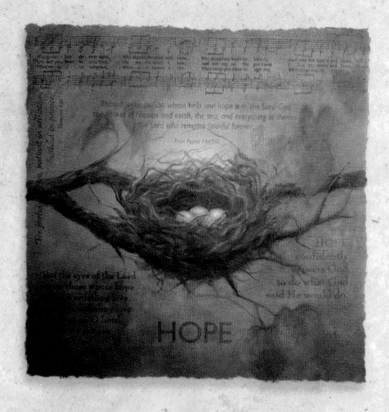

Love always hopes

Sing a new song of praise to him... and sing with joy.
For the word of the LORD holds true,
and we can trust everything he does.
He loves whatever is just and good;
the unfailing love of the LORD fills the earth.
We put our hope in the LORD.
He is our help and our shield.
In him our hearts rejoice, for we trust in his holy name.
Let your unfailing love surround us, LORD,
for our hope is in you alone.

Psalm 33:3-5, 20-22 NLT

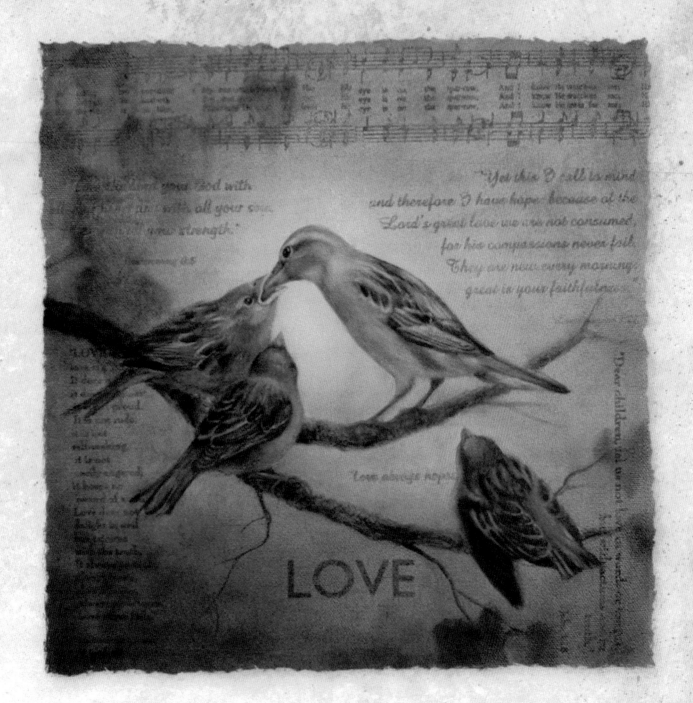

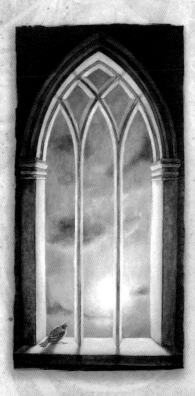

Therefore,
there is now no condemnation
for those who are in Christ Jesus,
because through Christ Jesus
the law of the Spirit of life set me free
from the law of sin and death.

Now the Lord is Spirit,
and where the Spirit of the Lord is,
there is freedom.

Romans 8:1-2
2 Corinthians 3:17 NIV

Freedom from self
Freedom to receive
Freedom to give
Freedom to live
by grace,
grateful to Christ
the Truth and
the Way of Life,
the One who set me Free –
Free to be me!

Praise the Lord!
I have escaped like a bird.
The cage is opened
and I've been set free,
free to fly.
My deliverer is the Lord,
maker of heaven and earth.

- based on Psalm 124:6-8

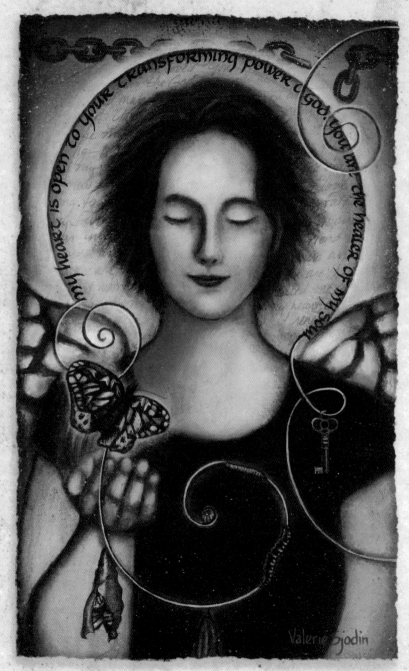

It is for freedom
that Christ has set us free.
Stand firm, then,
and do not let yourselves
be burdened again
by a yoke of slavery.

Galatians 5:1 NIV

And we all, who with unveiled faces
contemplate the Lord's glory,
are being transformed into
his image with ever-increasing glory,
which comes from the Lord,
who is the Spirit.

2 Corinthians 3:18 NIV

You are God,
My heart is open to your transforming power,
for you are the healer of my soul. I will trust you.
Wash me, cleanse me with living water.
Take my hurts, insecurities, fears,
and transform my heart to be like yours.
Conform my thoughts to your way of thinking.
I absolutely cannot do this without you. I am empty.
O Lord of hope, fill me with all joy and peace as I trust in You,
so that I may overflow with love
by the power of your Holy Spirit.

Your Child

3 domus

mirabile dictu

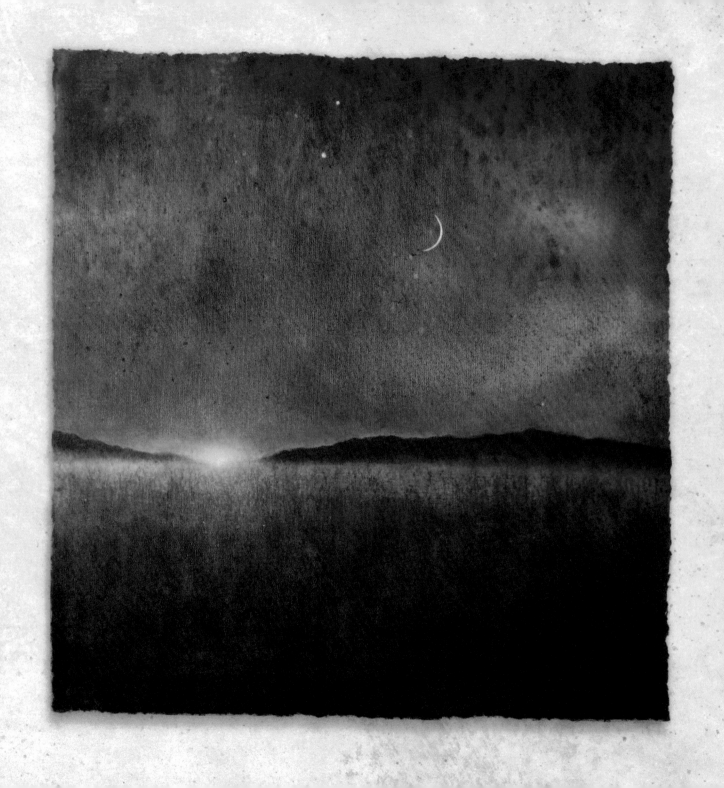

Show us your unfailing love,
O Lord, and grant us your salvation.
I listen carefully to what God the Lord is saying,
for he speaks peace to his faithful people.
But let them not return to their foolish ways.
Surely his salvation is near to those who fear him,
so our land will be filled with his glory.
Unfailing love and truth have met together.
Righteousness and peace have kissed!
Truth springs up from the earth, and
righteousness smiles down from heaven.
Yes, the Lord pours down his blessings.
Our land will yield its bountiful harvest.
Righteousness goes as a herald before him,
preparing the way for his steps.

Psalm 85:7-13 NLT

*"May the blessing of God Almighty,
the Father, the Son, and the Holy Spirit,
rest on us and on all our work and worship done in his name.
May he give us light to guide us, courage to support us,
and love to unite us, now and forevermore."*

author Unknown

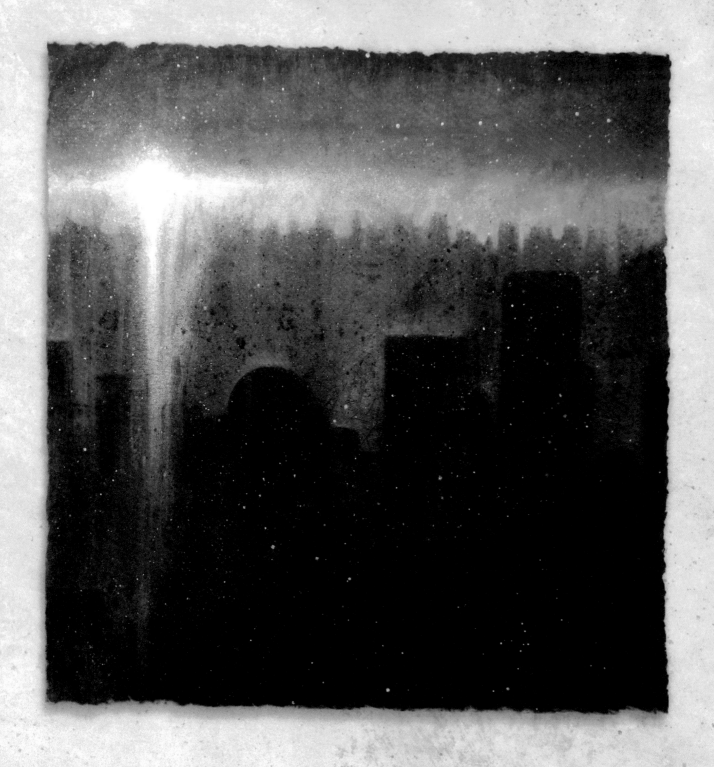

"O God, give me strength to live another day....
Let me not lose faith in other people;
keep me sweet and sound of heart in spite of
ingratitude, treachery, or meanness;
Preserve me from minding little stings or giving them;
help me to keep my heart clean and to live so honestly
and fearlessly that no outward failure
can dishearten me or take away the joy of conscious integrity.
Open wide the eyes of my soul that I may see good in all things;
Grant me this day some new vision of Thy truth;
Inspire me with the Spirit of joy and gladness;
and make me the cup of strength to suffering souls;
in the name of the strong Deliverer
our only Lord and Savior Jesus Christ."

~ from the Book of Common Prayer

Send out your light and truth; let them guide me.
Let them lead me to your holy mountain to the place where you live.
There I will go to the altar of God, to God--the source of all my joy.
I will praise you... O God, my God!
Why am I discouraged? Why is my heart so sad?
I will put my hope in God!
I will praise him again--my Savior and my God!

Psalm 43:3-5 NLT

I pray that your love will overflow more and more,
and that you will keep on growing
in knowledge and understanding.
For I want you to understand what really matters,
so that you may live pure and blameless lives
until the day of Christ's return.
May you always be filled with the fruit of your salvation—
the righteous character produced in your life by Jesus Christ—
for this will bring much glory and praise to God..

Philippians 1:9-11 NLT

O God, You have shown me how much You love me
by sending your one and only Son
into the world so that I might have eternal life through Him-
Life that begins and grows right now!
This is real love-
not that I loved You,
but You loved me and sent your only Son
as a sacrifice to take away my sins.

adapted from 1 John 4:9-10

The painting opposite was made during a time I was being tested for cancer and going through surgery. The story of the woman who quietly sought Jesus out for healing touched me deeply and encouraged me through that time of sickness and healing. I would pray this prayer over and over in the night (a combination of the "Jesus Prayer" and Jeremiah 17:14).

As Jesus went with him, he was surrounded by the crowds. A woman in the crowd had suffered for twelve years with constant bleeding, and she could find no cure. Coming up behind Jesus, she touched the fringe of his robe. Immediately, the bleeding stopped.

"Who touched me?" Jesus asked.

Everyone denied it, and Peter said, "Master, this whole crowd is pressing up against you."

But Jesus said, "Someone deliberately touched me, for I felt healing power go out from me."

When the woman realized that she could not stay hidden, she began to tremble and fell to her knees in front of him. The whole crowd heard her explain why she had touched him and that she had been immediately healed.

"Daughter," he said to her, "your faith has made you well. Go in peace."

Luke 8:42-48 NLT

Praise the LORD, my soul;
all my inmost being, praise his holy name.
Praise the LORD, my soul,
and forget not all his benefits—
who forgives all your sins and heals all your diseases,
who redeems your life from the pit
and crowns you with love and compassion,
who satisfies your desires with good things
so that your youth is renewed like the eagle's.
The LORD works righteousness and justice for all the oppressed.

Psalm 103:1-6 NIV

Lord Jesus Christ Son of God
have mercy on me a sinner.
Heal me Lord and I will
be healed; Save me and
I will be saved, for You
are the One
I praise.

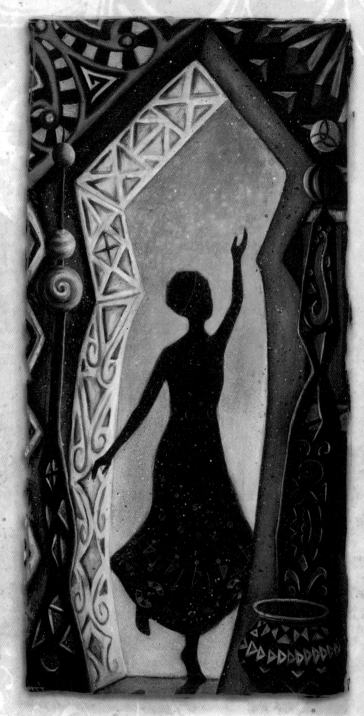

"And because
we are his children,
God has sent
the Spirit of his Son
into our hearts,
prompting us to call out,
"Abba, Father."
Now you are no longer a slave
but God's own child.
And since you are his child,
God has made you his heir."

Galatians 4:6-7 NLT

I AM GOD'S OWN CHILD

O LORD, even before You made the world,
You loved me and chose me in Christ
to be holy without fault in your eyes.
God, you decided in advance to adopt me
into your own family by bringing me
to yourself through Jesus Christ.
How can I ever thank you enough?

based on Ephesians 1:4-5

DADDY * PAPA * ABBA

For the Lord your God is living among you.
He is a mighty savior.
He will take delight in you with gladness.
With his love, he will calm all your fears.
He will rejoice over you with joyful songs.

Zephaniah 3:17 NLT

REJOICE WITH SINGING

My Child,
I am your light and truth,
giver of hope.
I have chosen you,
set you apart for my service.
Be open to my leading, to my heart. Let me guide you.
I am your inspiration, an ever-flowing river of ideas and endless beauty.
Walk in my freedom and receive my mercy.
Know I am walking with you on your journey.

Your loving Father

AIR MAIL

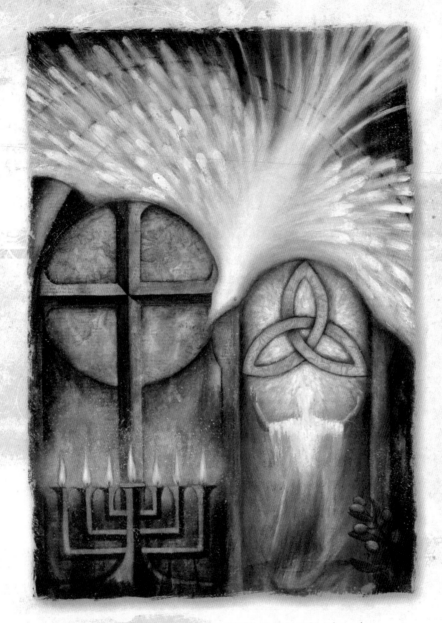

One thing I ask of the LORD, this is what I seek;
that I may dwell in the house of the LORD all the days of my life,
to gaze upon the beauty of the LORD and to seek him in his temple.

Psalm 27:4 NIV

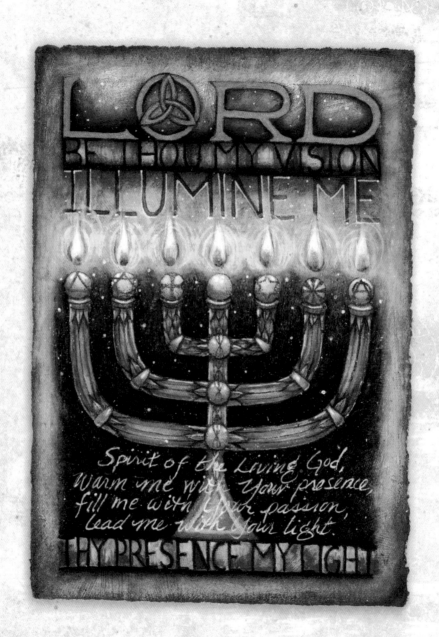

My Father,
Today I am soaking in
your Presence,
at peace and grateful for our time together.
I feel the glow of your love inside
as the warmth of the sun caresses my face.
I want to see more of your beauty O God,
to experience more of your grace and glory!
More of You, less of me.

Your grateful Child

AIR MAIL

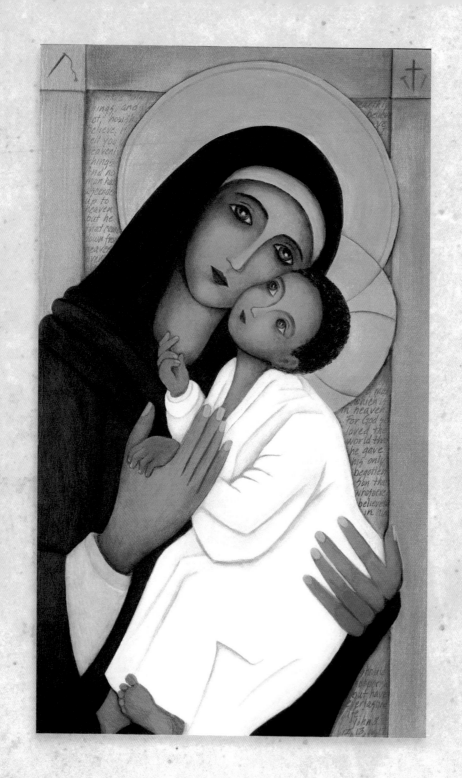

The angel Gabriel said to her,
"You are blessed because you believed that the Lord would do what he said."

Mary's Song of Praise

Mary responded, "Oh, how my soul praises the Lord.
How my spirit rejoices in God my Savior!
For he took notice of his lowly servant girl,
and from now on all generations will call me blessed.
For the Mighty One is holy, and he has done great things for me.
He shows mercy from generation to generation to all who fear him.
His mighty arm has done tremendous things!
He has scattered the proud and haughty ones.
He has brought down princes from their thrones and exalted the humble.
He has filled the hungry with good things and sent the rich away with empty hands.
He has helped his servant Israel and remembered to be merciful.
For he made this promise to our ancestors, to Abraham and his children forever."

Luke 1:45-55 NLT

'Speak LORD, for your servant is listening.'
Open the eyes of my heart to see your beauty.
Open the ears of my mind to hear your voice.
Fill me with your goodness, your loving presence, with grace and truth.
Here I am LORD, waiting, open, yearning for the advent of You.

So the Word became human and made his home among us.
He was full of unfailing love and faithfulness.

John 1:14 NLT

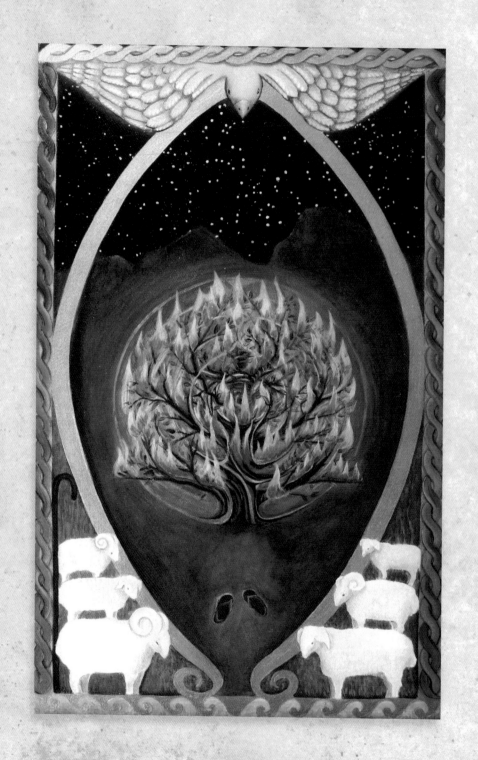

"Earth is crammed with heaven,
And every bush afire with God;
But only he who sees takes off his shoes,
The rest sit around it and pluck blackberries."

~ *Elizabeth Barrett Browning*

"...there is no place on earth where God's glory is not,
not even in a humble thorn bush."

~ *a Rabbi*

One day Moses was tending the flock of his father-in-law, Jethro, the priest of Midian. He led the flock far into the wilderness and came to Sinai, the mountain of God. There the angel of the Lord appeared to him in a blazing fire from the middle of a bush. Moses stared in amazement. Though the bush was engulfed in flames, it didn't burn up. "This is amazing," Moses said to himself. "Why isn't that bush burning up? I must go see it."
When the Lord saw Moses coming to take a closer look, God called to him from the middle of the bush, "Moses! Moses!"
"Here I am!" Moses replied.
"Do not come any closer," the Lord warned. "Take off your sandals, for you are standing on holy ground. I am the God of your father—the God of Abraham, the God of Isaac, and the God of Jacob." When Moses heard this, he covered his face because he was afraid to look at God.

Then the Lord told him,
"I have certainly seen the oppression of my people...
I have heard their cries of distress...
Yes, I am aware of their suffering.
So I have come down to rescue them ... and lead them...
Look! ...Now go, for I am sending you...
You must lead my people..."

~ from Exodus 3 NLT

Now may the God of peace~
who brought up from the dead
our Lord Jesus,
the great Shepherd of the sheep,
and ratified an eternal covenant
with his blood~may he equip you
with all you need
for doing his will.
May he produce in you,
through the power of Jesus Christ,
every good thing
that is pleasing to him.
All glory to him forever
and ever!
Amen.

Hebrews 13:20-21 NLT

I AM

~ a contemporary painting series

presenting symbols the

Lord Jesus Christ

used to represent himself ~
fulfillment of the Torah,
Savior of Humanity,
God incarnate

Yeshua Messiah

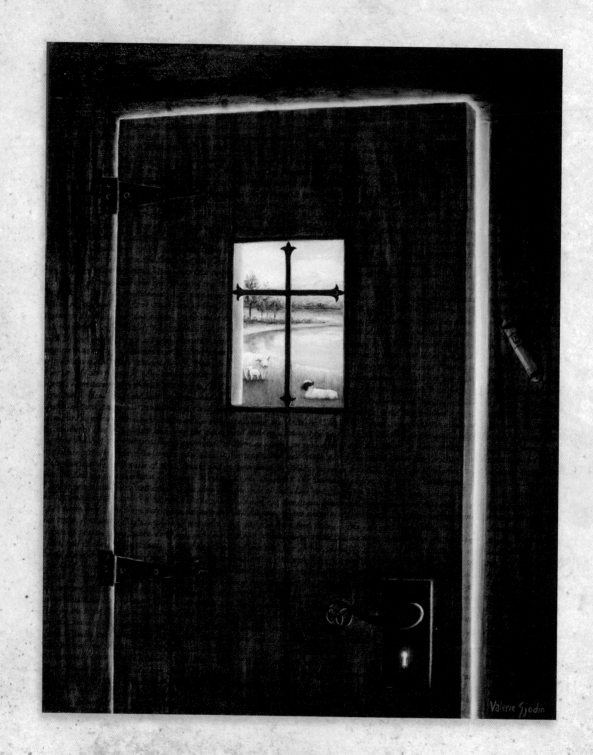

"Truly, truly, I say to you, I am the door of the sheep....
if anyone enters through Me, he shall be saved
and shall go in and out, and find pasture"

John 10:7, 9 NAS

This painting focuses on three powerful images, 'blood,' 'sheep,' and 'door,' which represent God's loving provision for His people.

In the Torah is found the account of the Passover, which began during the Jews' captivity in Egypt. God instructed the Israelites to sacrifice an unblemished lamb, placing some of its blood on the doorposts and lintels of their houses. The angel of death went through the doors of Egypt and killed the firstborn of every household except those who were covered by the blood of the lamb.

In the New Testament, the sacrifice and obedience were performed by Christ. He is the sacrificial lamb "who takes away the sin of the world." His obedience through the cross provides the way to peace and rest. While we are often described as sheep, He alone is the sacrifice. We, are recipients of the peace and rest found in His pasture (Psalm 23), for He is the "the good shepherd." A good shepherd lays down his life for the sheep. He is the "door" keeping out the wolves and thieves. He is the shepherd who will not flee, defending his sheep unto death.

The door is open. This is Yeshua's invitation to us to enter into the safety and redemption on the other side. The window is a glimpse of peace and rest in God's pasture. The cross is the way to the peace. "If anyone enters through Me, he shall be saved..."

Biblical text in the background:
Exodus 12:1-29, Psalm 121, Deuteronomy 6:4-9, 11:13-21, Psalm 84, Psalm 23, 118:13-14, 19-21, 28, John 1:29, 10:1-10, Hebrews 10:15-22, Matthew 7:7-8, 13-14, Revelation 3:20

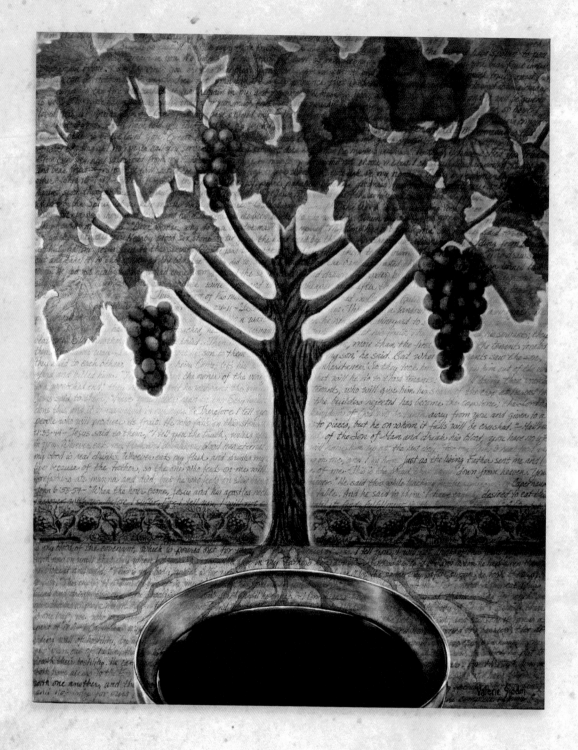

"I am the vine; you are the branches.
If you remain in me and I in you,
you will bear much fruit; apart from me you can do nothing."

John 15:5 NIV

The grapevine, both in first century Judaism and today, symbolizes the source of life and its celebration. I included the grapevine border for aesthetic reasons because it is a common symbol in many cultures, found in ornament and architecture--of fruitfulness. The grapevine here references the menorah with seven branches. The roots reach deeper to draw from the well of living water.

The vine takes the nourishment from the water and soil, channeling it through the branches to the fruit. In describing himself as the true vine, Yeshua helps them understand that He is their source of life and nourishment. His followers are the branches intended to produce fruit. A branch only produces fruit when attached to the vine.

It's fruit of the vine shared in community and fellowship. Yeshua transformed water into wine at a Jewish wedding celebration. Its deeper color is felt when Yeshua describes the wine of His last meal with His disciples as His blood, "drink from it, all of you. This is my blood of the covenant, which is poured out for many for the forgiveness of sins."

Biblical text in the background:
John 15:1-16, Galatians 5:22-25, John 2:1-11, Matthew 21:33-44, John 6:53-59,
Luke 22:14-18, Matthew 26:26-29, I Corinthians 11:24-26, I Corinthians 10:16-17, 12:27,
Ephesians 2:14-18, I John 1:7, 2:2

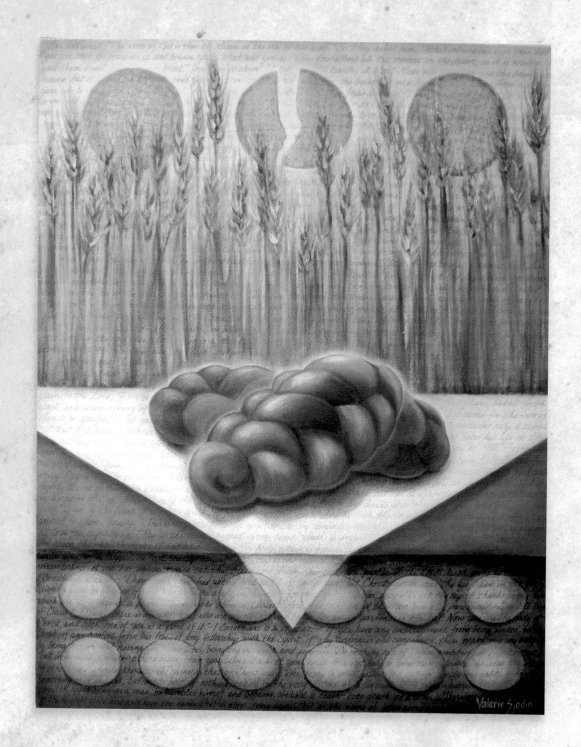

For the bread of God is he who comes down from heaven and gives life to the world.... I am the bread of life. He who comes to me will never go hungry, and he who believes in me will never be thirsty.

John 6:33,35 NIV

Twelve loaves of shew bread represent Jewish practice. In the Jewish temple twelve pieces of bread were placed upon a golden table representing each of Israel's tribes. They were placed in two rows signifying the Jews and Gentiles (or, all of humanity). In the painting, they remind us that Jesus came as the bread of life for Jews and Gentiles, everyone. The two loaves of challah bread represent the Pentecost festival. On the 50th day after the first sheaf of wheat was raised at harvest time, two loaves of leavened bread were placed on the shew bread table instead of the twelve unleaven loaves. The two symbolize humanity's sinfulness (the leaven) and hope of a redeemer.

In Messianic and Christian celebrations, the three pieces of matzoh represent the Trinity: Father, Son (Yeshua), and Holy Spirit. The second matzoh, representing Yeshua, is broken in two and the larger broken piece is called the "afikomen" meaning after supper, or dessert. It is wrapped and hidden in the house to be found later after the Passover meal. Yeshua's broken body was buried (hidden) in a tomb and was raised from the dead three days after the Passover.

With his disciples Yeshua took the second piece of matzoh bread and, in anticipation of his death, broke it saying, "Take, eat: this is My body, which is broken for you."

Biblical text used in the background: John 6:29-40, 44-51, 53-58; Hebrews 9:1-2, Leviticus 24:5-9, Exodus 34:21-22, Leviticus 23:15-17, John 12: 23-28, Luke 22:14-20, I Corinthians 11:24-26, Galatians 2: 20, I Corinthians 10:16-17, 12:27, Philippians 2:1-11.

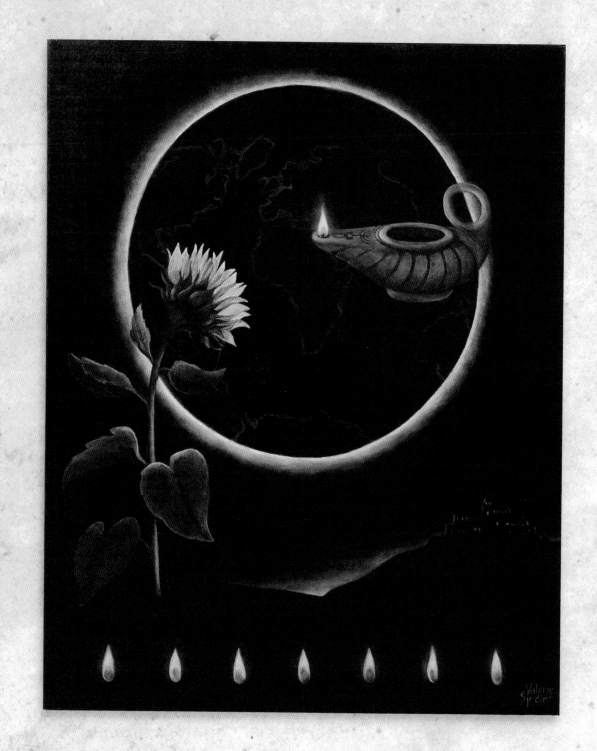

Jesus said, "I am the light of the world.
Whoever follows me will never walk in darkness,
but will have the light of life."

John 8: 12 NIV

One of my painting teachers said that to show the lightest lights you must contrast it with the darkest darks. The challenge of this piece was showing light in the darkness while retaining the readability of the text. I began with a painted red ground and put a wash of Paynes gray over it. Then I wrote the text on top. The darker landscape shapes contrast with the "floating" objects. My hope was to create a sense of mystery and unity with the "floating" objects while contrasting it with the darker horizon and city on the hill, giving the viewer a point of reference.

The globe represents the whole of humanity on earth, past, present, and future. The sunflower symbolizes the individual whose soul turns to the Light because the head of the sunflower will turn and follow the sun. It is also Yeshua, our example, coming to do only what the Father is doing. The oil lamp and the flame are a symbol of the dual nature of Jesus, fully human and fully divine. The flame is placed on the globe over Israel representing the life of Christ on earth. The city on the hill is a picture of the verses in Matthew 5:14,16 "You are the light of the world. A city on a hill cannot be hidden... let your light shine before men, that they may see your good deeds and praise your Father in heaven." It is a call to believers to live the kingdom of God. The seven flames at the base are symbolic of the light of God shining from the menorah: creation, the Jewish origin of Christianity, and the promise of eternal life.

Biblical text used in the background:
Genesis 1:1-4, Isaiah 42:5-7,16; Psalm 89:14-16, 4:5-6, 27:1-2, 18:27,28; 36:5,7,9; 139:7-12, Matthew 4:15-17, John 1:1-14; John 8:12, 12:35-37, 44-46; 3:19-21, Luke 8:16-17, Matthew 5:14-16, Ephesians 5:8-14, 1 Peter 2:9-10.

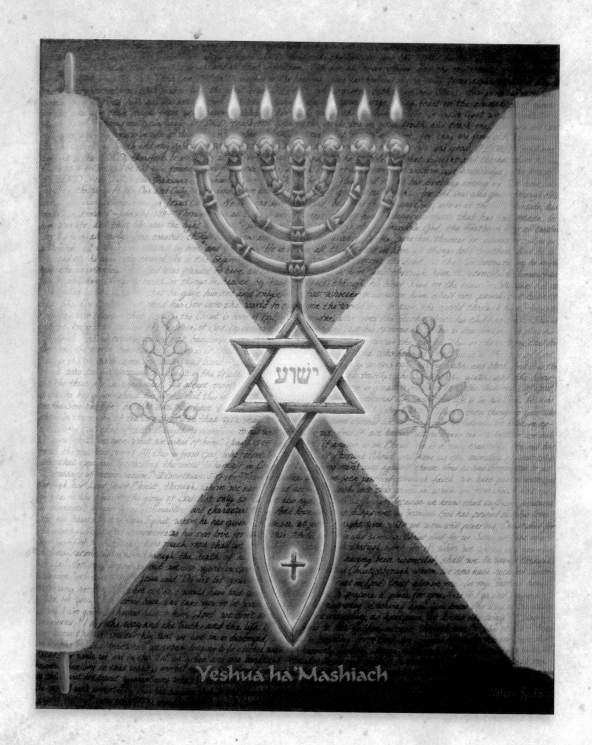

ישרע

Yeshua ha'Mashiach

"Lord, we don't know where you are going,
so how can we know the way?"
Jesus answered, "I am the way and the truth and the life.
No one comes to the Father except through me."

John 14: 5-6 NIV

I found that as I progressed in the series, my painting gradually moved from a representational style to one that was more conceptual and symbolic. This piece is of the latter, utilizing the Messianic Seal.

The central symbol, the Messianic Seal, was discovered on pottery and other items in an ancient grotto in Jerusalem near the site of the Upper Room: the meeting place of the Early Church. This three-part symbol contains the Menorah, the Star of David, and the Fish. The Hebrew text in the star's center is the name 'Yeshua.' Combined, it represents the Jewish foundation of Christianity and the intended unity of Jewish and Gentile believers.

The olive branches to each side of the Seal represent peace. An olive tree can live a few thousand years. Its trunk may die but its roots can still grow a shoot and another tree. Jesus is considered the shoot that has grown from the stump of Jesse.

"Yeshua ha 'Mashiach" is Hebrew for 'Jesus the Messiah.'

There is a scroll shape on the left signifying the Hebrew Scripture and a book on the right representing the New Testament. Yeshua is the one who is the fulfillment of the Messianic prophecy bringing unity and completeness to Jew and Gentile alike.

Biblical text in the background: Nehemiah 9:5-6, Psalm 36:5-9, 25:4-9, Isaiah 33:6, John 1:14, 3-4, 17-18, John 14:1-6, Colossians 1:15-20, John 3:16-17, 1 John 5:1-15, 2 Corinthians 5:17-19, Romans 5:1-11, 2 Corinthians 5:1-5, 53-55

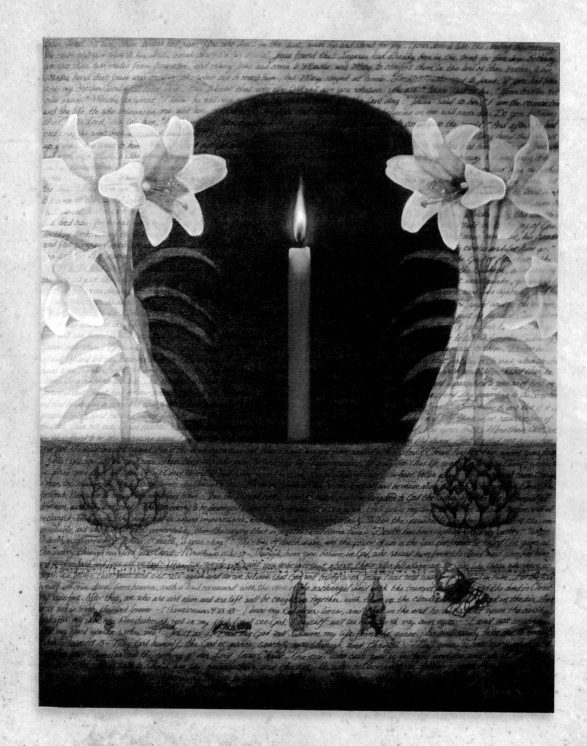

"I am the resurrection and the life.
The one who believes in me will live, even though they die;
and whoever lives by believing in me will never die. Do you believe this?"

John 11:25-26 NIV

I have chosen symmetrical compositions to emphasize the idea of a central, sacred focus often found in iconic imagery. In traditional iconic imagery, a religious icon serves as a stand-in for a holy figure. In this "I AM..." series, the symbols represented are intended to illustrate various characteristics of the claims and person of Yeshua the Messiah. The lit candle in the center represents the person of Yeshua: his divinity (light of the flame) and his humanity (the candle).

The black egg shape represents death and, the tomb where Jesus was placed after his crucifixion. The shape of the egg also alludes to the hope and process of life and being born. Easter lilies are a symbol of new life in our culture and are a traditional Christian symbol of resurrection. I chose to show the bulbs in the ground because in order for a bulb to grow into a flower it must "die" and be buried. Only then does it bloom into something much more beautiful. The metamorphosis of a butterfly signifies the mystery of death to produce new life. The sunrise communicates the hope of a new day and a new life in Christ.

Turning to the grief stricken sister of the dead man Lazarus, Yeshua tells Martha that Lazarus, "shall rise again." Martha waxes theological admitting that they will all be resurrected in the end. Yeshua draws her back into the present saying, "I am the resurrection and the life. He who believes in me will live, even though he dies; and whoever lives and believes in me will never die. Do you believe this?"

Biblical text used in the background:
Isaiah 26:19, Psalm 49:15, John 11: 17-44, Matthew 22:31-32, 28:1-10,
I Corinthians 15:3-7, 12-26, 35-58; I Peter 1:21-25, I Thessalonians 4:13-18, 5:23-25,
Philippians 3:7-10, Job 19:25-27, II Corinthians 3:18

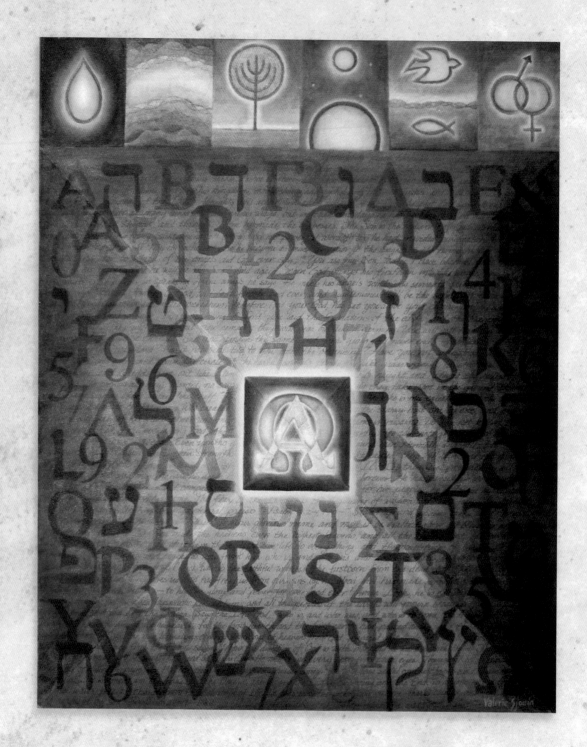

"I am the Alpha and the Omega," says the Lord God,
"who is, and who was, and who is to come, the Almighty."

Revelation 1:8 NIV

I approached this painting conceptually, in symbolic terms, with the idea of eternity or someone being "the beginning and the end" as beyond my grasp. Time is suggested by the use of pattern and sequence. The structure is formal, symmetrically balanced. An "X" shaped composition is used, with an upper horizontal border of six equal sections. Lighter values and warmer colors used above and below create movement allowing the eye to rest at the top and center while traveling through the layers. The warm and cool colors and value contrasts are a shifting system to help organize the space. Layering text, symbols, transparent colors, and values visually tie the work to the other paintings in the series.

Six creation days bring us light, atmosphere, land and sea, sun, moon, stars, birds, fish, animals, woman and man. They are our "beginning." The seventh day is represented by the alpha & omega symbol in the center, and communicates completeness and contentment.

Layered alphabets in Greek, Hebrew and English, represent ideas and time. Greek 'alpha' and 'omega' letters mean the beginning and the end in Christian symbolism. Hebrew is used out of respect for Christianity's Jewish roots, Christ himself a Jew. English, my native language, is recognized across cultures. Numbers suggest infinity, "who is and who was and who is to come..."

Biblical text used in the background:
John 1:1-5, 16-18, Colossians 1:15-20, Isaiah 9:6-7, Hebrews 1:1-12, Isaiah 40:21-31, Psalm 111:2-10, Revelation 1:4-8, John 8:58

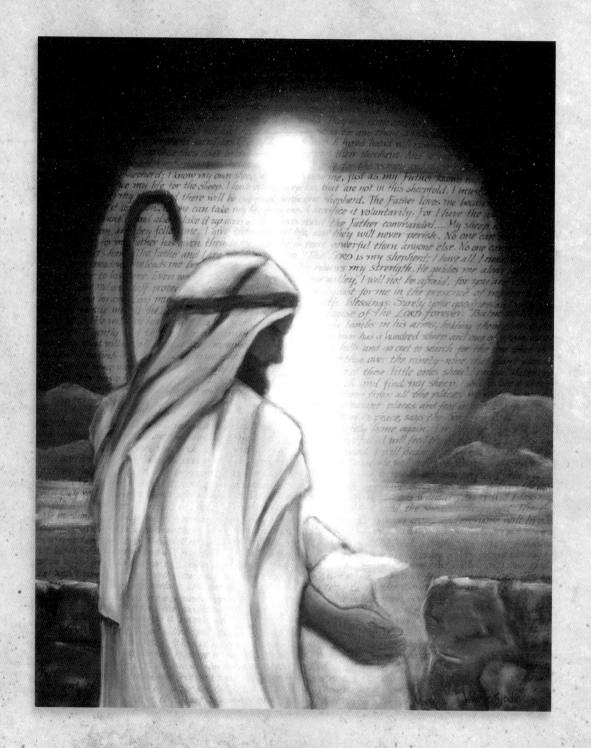

*"I am the good shepherd; I know my own sheep, and they know me,
just as my Father knows me and I know the Father.
So I sacrifice my life for the sheep."*

John 10:14-15 NLT

This painting came seven years after the others were displayed. Like the others, it involves symbolism and relevant Scripture hand-written on the background. Also, like the others, I worked to experience the symbolism, but it took me seven years to fully experience the love of my Good Shepherd.

In the spring of 2011 at a creativity conference, a young woman named Stephanie sang about the Good Shepherd and my imagination was captured. I saw the composition in my mind, the sheep looking at the shepherd; the shepherd's hand on the sheep. It was time to paint the final "I AM" found in John 10. I had been saving a canvas, the same size as the others for a few years, in faith that at some point I would be painting Jesus as my Good Shepherd.

A few days after I came back home, I got the canvas out and roughly drew a charcoal sketch of the idea. At our home group that evening I told them about the Good Shepherd experience and asked for prayer about my upcoming event, "evening with the artist," where I would be talking about the I AM series. It was strongly suggested I bring the unfinished Good Shepherd painting to encourage someone. I first thought, "No way, it's just a rough sketch. It took me a month or more to do each of the others and the presentation is tomorrow. That's breaking all the art presentation rules. No!" But then I thought, "What if it does encourage someone? Am I willing to put my perfectionism aside and risk it?" I heard the still small voice say, "Be open, you will not be painting alone." So the next morning, rising earlier than usual, I made my way to the studio asking the Holy Spirit to lead the project. I was still painting at 4:45 pm and needed to leave for the art presentation at 5:15. As I got in the car with the painting, I was thinking, "This must be a God thing. It's too bizarre."

At the church, I put the painting on an easel and covered it with a cloth. I talked a bit and we had a great discussion. I gained a lot of insight from the experience of others. When I unveiled the "I AM the Good Shepherd" the discussion went deeper. It was sweet, vulnerable, and I felt incredibly humbled and blessed. The painting is not perfect, but it is personal.

Biblical text used in the background: John 10:1-18, 27-30; Psalm 23, Isaiah 40:11, Matthew 18:12-14, Ezekiel 34, I Peter 2

Jesus and the Samaritan Woman~

the longest one-on-one conversation
between Jesus and another person recorded in the Gospels

Jesus knew the Pharisees had heard that he was baptizing and making more disciples than John (though Jesus himself didn't baptize them—his disciples did). So he left Judea and returned to Galilee.

He had to go through Samaria on the way. Eventually he came to the Samaritan village of Sychar, near the field that Jacob gave to his son Joseph. Jacob's well was there; and Jesus, tired from the long walk, sat wearily beside the well about noontime. Soon a Samaritan woman came to draw water,

John 4:1-7a NLT

Imagine yourself as this Samaritan woman, a kind of outcast, having to go and fetch water every day and dreading it for a number of reasons (the five husbands, the gossip, the possible ex-wife of the third husband etc.), not to mention the physical aspect of carrying heavy water. To make it easier on yourself and everyone else you go to the well when the other women are less likely to be there, even though it is in the heat of the day.

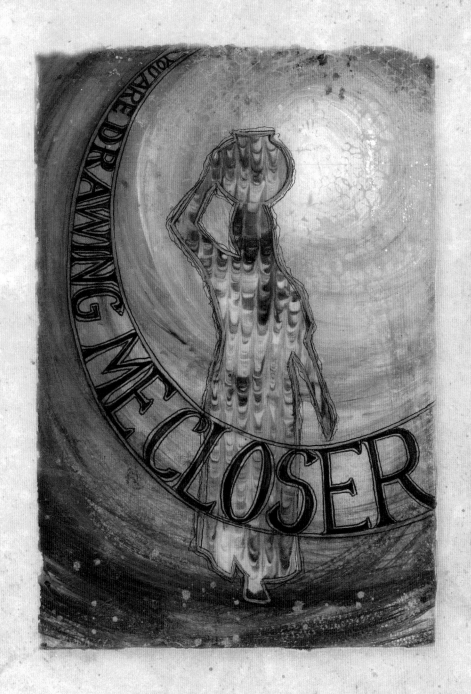

... and Jesus said to her, "Please give me a drink." He was alone at the time because his disciples had gone into the village to buy some food.

The woman was surprised, for Jews refuse to have anything to do with Samaritans. She said to Jesus, "You are a Jew, and I am a Samaritan woman. Why are you asking me for a drink?"

Jesus replied, "If you only knew the gift God has for you and who you are speaking to, you would ask me, and I would give you living water."

"But sir, you don't have a rope or a bucket," she said, "and this well is very deep. Where would you get this living water? And besides, do you think you're greater than our ancestor Jacob, who gave us this well? How can you offer better water than he and his sons and his animals enjoyed?"

John 4:7-12 NLT

Arriving at the well, a man is sitting there, obviously a Jew. You think, "In his mind I am of no more value than a dog. I'll just get my water and go home." To your surprise, the man asks you for a drink of water. What is he thinking? He seems different, not like any man you've met before. He feels safe.

You ask him why a Jewish man would even speak to a Samaritan woman.

This man named Jesus replies, If YOU only knew the GIFT God has for YOU and who YOU are speaking to, YOU would ask ME and I would give YOU LIVING WATER.

Jesus says the word 'you' to the woman five times in this sentence. Put your name in the place of 'you.' Can we doubt the living God wants a relationship with us, to be in conversation with each of us as individuals? The word gift in Greek is Dorea. It denotes a free undeserved, unwarranted gift. Whenever it is used in the New Testament it is used referring to a spiritual or supernatural gift: here it is living water.

Springs and wells provided continually renewed water for the community. They are a metaphor acknowledging God as the flowing source of living water, His holy presence with us. The Bible refers to water being used in three different ways: as an immense force controlled by God, a source of life, and a cleansing agent. That is also true of the Holy Spirit's work in our lives.

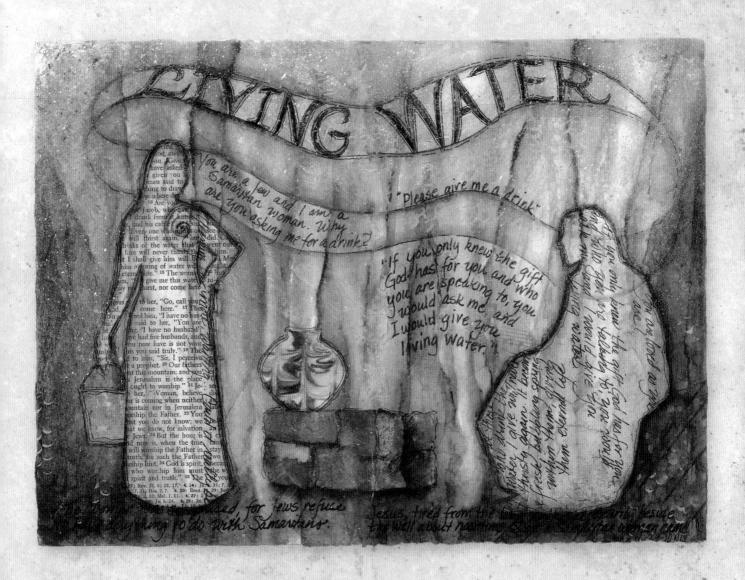

Jesus replied, "Anyone who drinks this water will soon become thirsty again. But those who drink the water I give will never be thirsty again. It becomes a fresh, bubbling spring within them, giving them eternal life."

"Please, sir," the woman said, "give me this water! Then I'll never be thirsty again, and I won't have to come here to get water."

John 4:13-15 NLT

In John 14 Jesus tells his disciples that He is soon sending a helper, an Advocate, "the Holy Spirit, who leads into all truth." The word truth, "aletheia" means "not covered". Jesus uncovered the truth about the woman: her sinful lifestyle and other things about her, telling her things he would have never known in the natural realm.

We are just like her, because when we are willing, the Spirit of truth confronts the lies we believe and reveals the truth to us about God and the truth of our own identity. I believe that is what happened between the woman at the well and the Lord Jesus that day. He revealed to her who God is and who she is in God's eyes: completely known and loved by God. That is why instead of hiding her shame, or blaming others for her choices, she was able to experience forgiveness and restoration to such a degree that she was compelled to share the good news with the very neighbors she was likely trying to avoid. She came to understand Jesus is the embodiment of truth, the living God, and He was offering her an intimate life in communion with His Spirit that would enable her to live a life of obedience.

Jesus is offering us the same gift he offered her: living water, which is the Holy Spirit. In John 4:14 Jesus says, "...those who drink the water I give will never be thirsty again. It becomes a fresh bubbling spring within them, giving them eternal life." Through the Holy Spirit we can have continual renewal and fellowship with Him. Eternal life means a perpetual life extending to the healing of the past, having a fulfilling life in the present, and hope for the future.

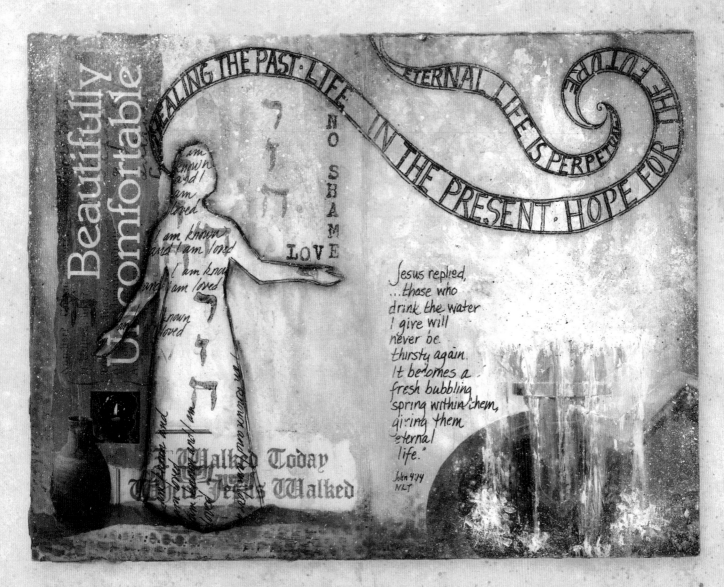

For you are the fountain of life, the light by which we see.

~ Psalm 36:9 NLT

"Go and get your husband," Jesus told her.

"I don't have a husband," the woman replied.

Jesus said, "You're right! You don't have a husband—for you have had five husbands, and you aren't even married to the man you're living with now. You certainly spoke the truth!"

"Sir," the woman said, "you must be a prophet. So tell me, why is it that you Jews insist that Jerusalem is the only place of worship, while we Samaritans claim it is here at Mount Gerizim, where our ancestors worshiped?"

Jesus replied, "Believe me, dear woman, the time is coming when it will no longer matter whether you worship the Father on this mountain or in Jerusalem. You Samaritans know very little about the one you worship, while we Jews know all about him, for salvation comes through the Jews. But the time is coming—indeed it's here now—when true worshipers will worship the Father in spirit and in truth. The Father is looking for those who will worship him that way. For God is Spirit, so those who worship him must worship in spirit and in truth."

The woman said, "I know the Messiah is coming—the one who is called Christ. When he comes, he will explain everything to us."

Then Jesus told her, "I Am the Messiah!"

John 4:16-26 NLT

Toward the end of the conversation, she turns to the subject of worship and the differences between the Jews and the Samaritans. Jesus breaks down the barriers by redefining worship from a physical exterior location and ritual to an interior heart-felt worship of the Father in Spirit and truth, our spirit connecting with His Spirit, agreeing with Him. In verse 24 Jesus says, "God is spirit, and his worshipers must worship in spirit and in truth.

The Greek word for spirit is "pneuma" (wind, breathe, invisible, powerful. It also means that by which a person perceives, reflects, feels, and desires.) Truth, the Greek word is "aletheia", as the truth of the Gospel, God's promises exhibited in Christ the embodiment of the truth, the Word of God. Jesus declares this truth to her: he is the Messiah they have been waiting for....

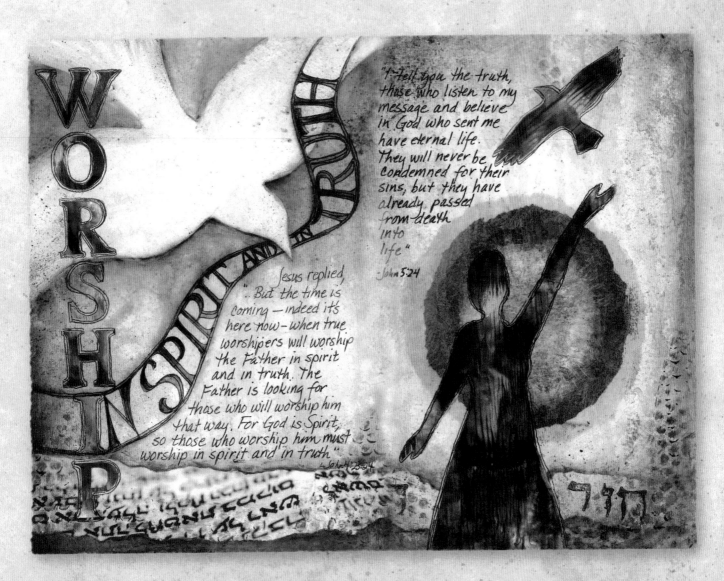

I tell you the truth, those who listen to my message and believe in God who sent me have eternal life. They will never be condemned for their sins, but they have already passed from death into life.

John 5:24 NLT

Just then his disciples came back. They were shocked to find him talking to a woman, but none of them had the nerve to ask, "What do you want with her?" or "Why are you talking to her?"

The woman left her water jar beside the well and ran back to the village, telling everyone, "Come and see a man who told me everything I ever did! Could he possibly be the Messiah?" So the people came streaming from the village to see him.

Meanwhile, the disciples were urging Jesus, "Rabbi, eat something."

But Jesus replied, "I have a kind of food you know nothing about."

"Did someone bring him food while we were gone?" the disciples asked each other.

Then Jesus explained: "My nourishment comes from doing the will of God, who sent me, and from finishing his work. You know the saying, 'Four months between planting and harvest.' But I say, wake up and look around. The fields are already ripe for harvest. The harvesters are paid good wages, and the fruit they harvest is people brought to eternal life. What joy awaits both the planter and the harvester alike! You know the saying, 'One plants and another harvests.' And it's true. I sent you to harvest where you didn't plant; others had already done the work, and now you will get to gather the harvest."

John 4:27-38 NLT

I find it amazing that she leaves her water jug, like her old life, behind. Then she runs to tell her neighbors, "Come and see a man who told me everything I ever did."

If I were one of her neighbors I would've wondered, "Is that a good thing that he told her everything?" But she obviously found grace and forgiveness rather than guilt and shame. She follows that statement with, "Could this be the Messiah, the Christ?" Her focus is not on herself but on the Lord Jesus Christ, the fulfillment of their hope, and on sharing this good news with her neighbors.

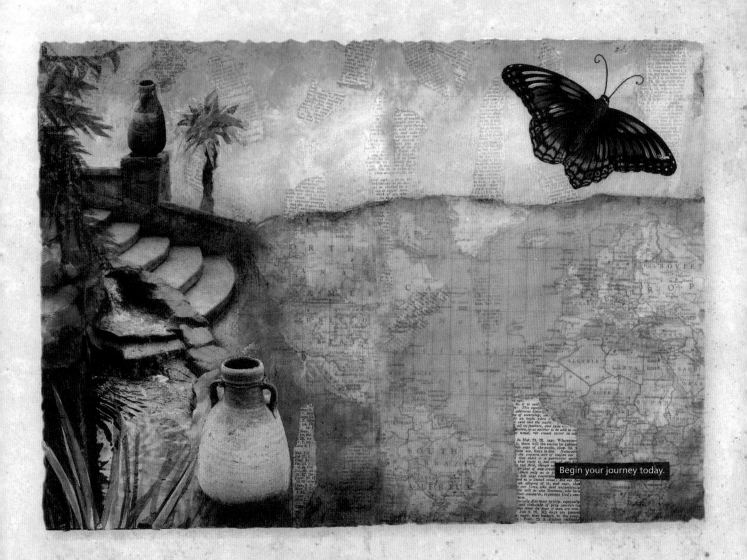

Begin your journey today.

Many Samaritans from the village believed in Jesus because the woman had said, "He told me everything I ever did!" When they came out to see him, they begged him to stay in their village. So he stayed for two days, long enough for many more to hear his message and believe. Then they said to the woman, "Now we believe, not just because of what you told us, but because we have heard him ourselves. Now we know that he is indeed the Savior of the world."

John 4:40-42 NLT

When I think of all this,
I fall to my knees and pray to the Father,
the Creator of everything in heaven and on earth.
I pray that from his glorious, unlimited resources
he will empower you with inner strength through his Spirit.
Then Christ will make his home in your hearts as you trust in him.
Your roots will grow down into God's love and keep you strong.
And may you have the power to understand, as all God's people should,
how wide, how long, how high, and how deep his love is.
May you experience the love of Christ,
though it is too great to understand fully.
Then you will be made complete with all the fullness of life
and power that comes from God.

Ephesians 3:14-19 NLT

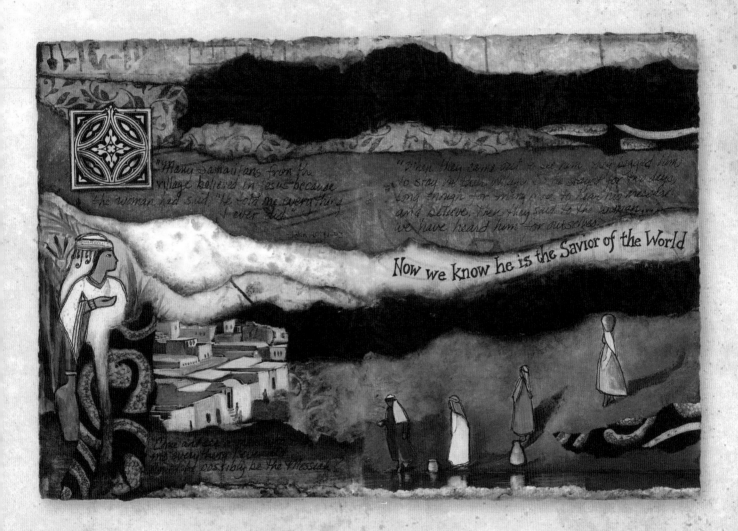

"Many Samaritans from the village believed in Jesus because the woman had said "He told me everything I ever did."

John 4:39-42

"When they came out to see him, they begged him to stay in their village, and he stayed for two days, long enough for many more to hear his message and believe. Then they said to the woman, "we have heard him for ourselves."

Now we know he is the Savior of the World

"Come and see a man who told me everything I ever did. Could he possibly be the Messiah?"

"Why did Christ call the grace of the Spirit water?
Because by water all things subsist;
because water brings forth grass and living things;
because the water of the showers comes down from heaven...
because it comes down in one form
but works in many forms...
it becomes white in the lily, red in the rose,
purple in the violets and hyacinths,
different and varied in each species.
It is one thing in a palm tree,
yet another in a vine,
and yet in all things."

Cyril of Alexandria

Oh, that we might know the LORD!
Let us press on to know him.
He will respond to us as surely as the arrival of dawn
or the coming of the rains in early spring.

Hosea 6:3 NLT

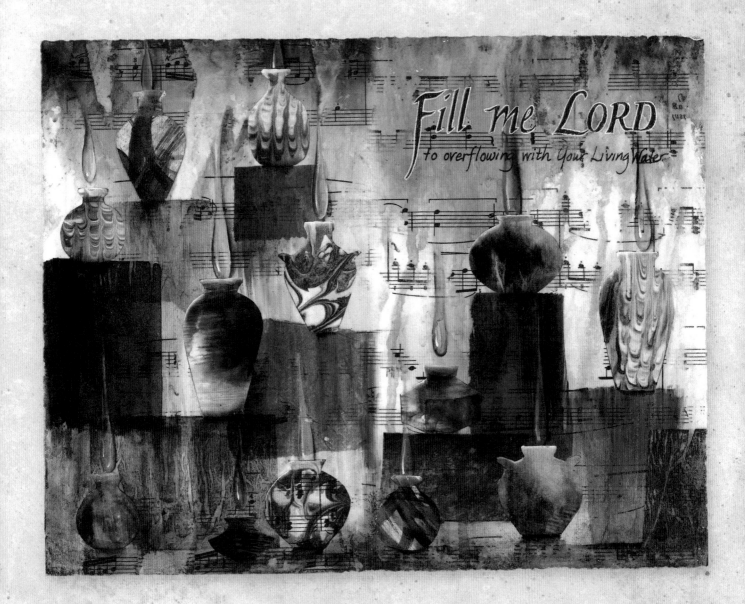

Then Jesus said,
"Come to me, all of you who are weary
and carry heavy burdens, and I will give you rest.
Take my yoke upon you. Let me teach you,
because I am humble and gentle at heart,
and you will find rest for your souls.
For my yoke is easy to bear,
and the burden I give you is light."

Matthew 11:28-30 NLT

"Anyone who is thirsty may come to me!
Anyone who believes in me may come and drink!
For the Scriptures declare,
'Rivers of living water will flow from his heart.'"

(When he said 'living water' he was speaking of the Spirit,
who would be given to everyone believing in him.)

John 7:37-39 NLT

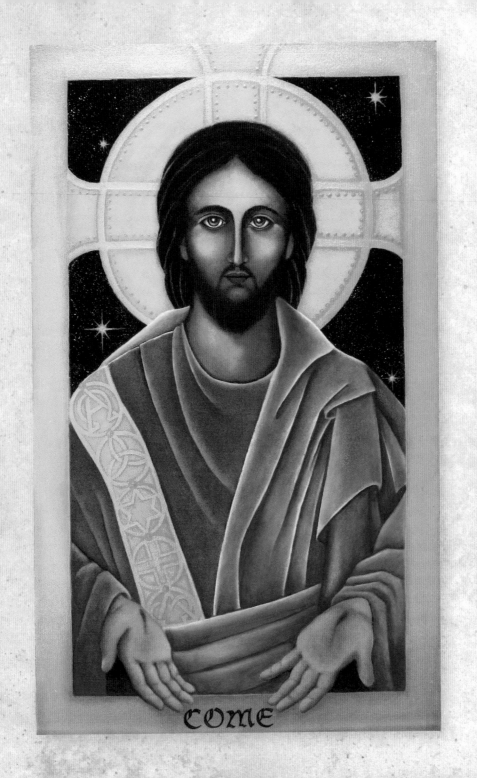

COME

"O God,"
I said, and that was all.
But what are the prayers
of the whole universe
more than expansions of that one cry?
It is not what God can give us,
but God that we want."

~ George MacDonald

Made in the USA
San Bernardino, CA
13 July 2014